SMART
OBJECT
PIPELINE

SMART OBJECT PIPELINE

Revolutionary Tactics for the Photoshop Layer Workflow

by Ted Dillard

LARK BOOKS

A Division of Sterling Publishing Co., Inc.

New York / London

Editor: Kara Helmkamp
Book Design: Ginger Graziano
Cover Design: Thom Gaines – Electron Graphics

Library of Congress Cataloging-in-Publication Data

Dillard, Ted, 1956-
 Smart object pipeline : revolutionary tactics for the Photoshop workflow /
Ted Dillard. -- 1st ed.
 p. cm.
 Includes index.
 ISBN 978-1-60059-397-0 (pbk. : alk. paper)
 1. Adobe Photoshop. 2. Photography--Digital techniques--Outlines,
syllabi, etc. 3. Raw file formats (Digital photography) 4. Workflow. 5.
Art objects. I. Title.
 TR267.5.A3D564 2009
 775--dc22

 2008045460

10 9 8 7 6 5 4 3 2 1

First Edition

Published by Lark Books, A Division of
Sterling Publishing Co., Inc.
387 Park Avenue South, New York, N.Y. 10016

Dedicated to my mom and dad

Distributed in Canada by Sterling Publishing,
c/o Canadian Manda Group, 165 Dufferin Street
Toronto, Ontario, Canada M6K 3H6

Distributed in the United Kingdom by GMC Distribution Services, Castle Place, 166 High Street, Lewes, East Sussex, England BN7 1XU

Distributed in Australia by Capricorn Link (Australia) Pty Ltd., P.O. Box 704, Windsor, NSW 2756 Australia

If you have questions or comments about this book, please contact:
Lark Books
67 Broadway
Asheville, NC 28801
(828) 253-0467

Manufactured in China

For information about custom editions, special sales, premium and corporate purchases, please contact Sterling Special Sales Department at 800-805-5489 or specialsales@sterlingpub.com.

SMART OBJECT PIPELINE

Revolutionary Tactics for the Photoshop Layer Workflow

TABLE OF CONTENTS

Introduction ... 10

BOOK 1: FOUNDATION ... 15

PRIMER: Non-Destructive Editing, The Digital Latent Image,
and Metadata ... 16

Chapter 1: The RAW Deal .. 18

Why Use Smart Objects? ... 19
The RAW File ... 20
Contrast, Color & Scaling: Three Steps to RAW Processing 23
Tricks and Tips ... 24
Examples: Watch the Histogram ... 25
GEEKZONE: Bit Depth ... 28
GEEKZONE: Color Management Settings 32

Chapter 2: Adobe Camera RAW ... 36

The Definitive Camera RAW Primer .. 37
Toolbar ... 39
 Zoom Tool .. 39
GEEKZONE: Get the Zoom Right .. 40
 Hand Tool .. 42
 Eyedroppers .. 42
 Crop Tool .. 43
 Straighten Tool .. 44

Retouch Tool..45

Red Eye Removal Tool...45

GEEKZONE: Camera RAW CS4: The Adjustment Brush46

Camera RAW Preferences Button.......................................50

Rotate Buttons..51

Variations on the Tools...51

The Info Window ..52

Preview and Full Screen Buttons.......................................52

Histogram...52

Buttons and Workflow Options ..54

Save Image Button ...54

Open Object, Cancel, and Done Buttons............................54

Workflow Options Link...54

Open in Photoshop as Smart Object55

Filmstrip or Thumbnails...55

Camera RAW Adjustment Tabs..56

The Basic Tab...56

Color Adjustments ...57

White Balance...57

Temperature..57

Tint...57

Contrast Adjustments...62

Exposure ...62

Blacks...64

Brightness ...64

Contrast ..67

Recovery and Fill Light ...69

The Tone Curve Tab ...70

The Detail Tab..73

The HSL/Grayscale Tab ...74

Hue..75

Saturation ...77

Luminance...78

The Camera Calibration Tab..83

GEEKZONE: News Flash: Adobe Camera RAW version 5.284

The Split Toning and Lens Correction Tabs............................88

The Presets Tab (and Settings)..89

Conclusion..90

GEEKZONE: Adobe Bridge Revealed92

Chapter 3: Photoshop Layers and Masking100

Understanding Layers ...101

Understanding Masks ...104

Example: Masking a Photograph107

Basic Adjustment Layer Masking Steps111

Making the Mask With a Selection114

GEEKZONE: The Mask Panel...118

Chapter 4: The Smart Object ...120

What is the Smart Object? ...121

The Smart Object Menu ...125

 Convert to Smart Object125

 New Smart Object via Copy126

 Edit Contents ..126

 Export Contents ..126

 Replace Contents ...126

 Rasterize ..126

GEEKZONE: XMP and Metadata...128

Book 1 Conclusion..130

BOOK 2: THE SMART OBJECT CORE 133

Chapter 5: The Smart Object Core 134

Smart Objects: What We Can and Can't Do 138

 Can Do .. 138

 No Can Do .. 140

Examples: A Standard Workflow .. 144

GEEKZONE: Sharpening Strategies .. 152

Chapter 6: Adding Layers ... 156

The Smart Object Core: Adding Layers .. 157

Placing Layers .. 161

Chapter 7: Masks and Selections 164

Creating Masks ... 166

Creating Masks With Selections .. 170

Chapter 8: Workflow Strategy 176

Developing a Consistent Approach ... 177

 The Source Layer ... 177

Example: Unsharp Mask Adjustment .. 178

Smart Object Cloning and Healing ... 183

The "Merge Visible" Gambit ... 187

GEEKZONE: The Rosenholtz-Sanchez Effect 190

BOOK 3: ADVANCED TECHNIQUES 197

Chapter 9: Smart Moves and Layer Features 198

JPEGs in the Smart Object Workflow ... 199

The (Super Secret Smart) Aliasing/Noise Fix 202

Getting Organized: Layer Groups .. 205

Blending Modes...208

GEEKZONE: Cropping Quandaries..210

Chapter 10: Smart Filter Layers ..212

Copying Smart Filters from Layer to Layer213

Multiple Smart Filters ...215

Smart Filter Masks..220

GEEKZONE: Smart Objects Plug-In Support: Nik Software..................226

Chapter 11: An Introduction to Actions228

Creating Keyboard Shortcuts ...235

GEEKZONE: Lightroom ...238

Chapter 12: Variations and Archiving.................................240

Down the Rabbit Hole of HDR Processing............................241

Smart Objects: Getting to Dynamic Range242

GEEKZONE: Alternate Processing, Smart Objects,
and the Old "Pin Register" Trick..250

Archival Challenges with the Smart Object Process252

GEEKZONE: The DNG File ...258

Chapter 13: The Big Picture ..262

A Complete Smart Object Workflow Example........................263

Conclusion..279

Appendix...280

Index ..286

SMART OBJECT PIPELINE

Welcome to the New World of Smart Objects!

e have arrived at what I consider to be the most profound turning point in the entire development of digital photography to date—the RAW file. This has changed the way we approach photography, the way we create images, and the processes we use to produce a final print. Just as 35mm film did for photography, the RAW file has introduced a new and different way to make a photograph, and we have to learn new methods to handle that technology. The Smart Object process creates a better way to get at the RAW file and massage the editing workflow.

Smart Objects allow photographers to directly access the RAW file in a seamless, efficient processing path for the first time—a path I call the Smart Object Pipeline. This pipeline utilizes the power of RAW processing (a constructive editing process) to get back to the "digital latent image" with the click of a mouse. Add this pipeline to a solid Layers and Layer Mask workflow and you have an all-new and remarkably powerful way to get the most out of any image file.

This is an innovative, fully evolved, and complete process, but it will almost certainly mean changing the way you digitally edit images. Most of the classes I teach are for upper-level undergraduate and graduate photography students, and by the time they get to me, they have pretty solid footing in Photoshop. I usually start out my classes by saying, "Bear with me; I know your Photoshop skills are well-established and that you have your favorite methods, and that's great. But for this semester, I want you to do it my way. After that—after you learn the whole system and this class is over—you can go back to your favorite tools and processes if you choose."

Throughout the development of a remarkable tool like Photoshop, the tool evolves. It does not work like it did when it was introduced, or even when you learned how to use it. I learned Photoshop on version 3. (I picked it up just to make a web page; I never thought it would set me free of the darkroom!) Most of the tools—including RAW processing, Layers, Masks, and even fundamental color management—did not exist. As Adobe developed these tools, I was forced to relearn my processing techniques. Just as Photoshop continues to develop, you've got to continually examine your old ways of working and ask yourself if it is time to rethink the whole thing. Sticking with old habits or ways of working could be costing you a lot of time and freedom.

I have created this workflow mostly by what I call the "hacker" method: I tear into the program and try things out—it is how I learn.

I occasionally refer to books like this (or my favorite over the years, the late Bruce Fraser's *Real World Photoshop* series), if I get stuck. This trial and error method is a long and random road to achieving a solid set of strategies. Sometimes, left to hacking alone, you never get there. But you gain the benefit of my experiments; I have culled out the unnecessary steps and pulled together the techniques and processes that I find are most important for a solid editing method: The Smart Object Pipeline.

The Smart Object process is still being refined (just as software developers constantly work to improve Photoshop and the Creative Suite), but it stands independently as a complete and professional way to work. It functions solely on the philosophy of the "non-destructive" workflow and uses the highest levels of image processing techniques.

My challenge to you: Bear with me. I'll take you through the foundations of this process—the RAW file, RAW processing, layers, and masks—and show you the techniques and strategies that I use. Try it out for yourself. It's a new way to work, which means you'll probably break a few old habits and develop some new ones. Keep in mind that the advantage of this process is that it is based on a very select set of tools and can be applied to any method a photographer might use to create remarkable images.

Ansel Adams, a photographer with a remarkable vision and a consummate technician and teacher, said this:

"I believe that the electronic image will be the next major advance. Such systems will have their own inherent and inescapable structural characteristics, and the artist and functional practitioner will again strive to comprehend and control them."

He said this in 1981, shortly before he passed away, belying his lifelong effort to stay on the very forefront of the photographic process. Even then photography demanded constant attention to understanding the latest tools, techniques, and materials. That applies now more than ever before.

I don't I feel this is a process that is only for the advanced user. I've started beginner classes right out with RAW file processing, Layers, Masks, and Smart Objects, and they pick it up faster than the old way, telling me that it is, indeed, a great way to work. (In fact, photographers just starting out may have an easier time of learning this, since they have fewer bad habits to break.)

So step right up, leave your preconceptions behind you, and enter the *Smart Object Pipeline*.

BOOK 1:
FOUNDATION

There are three cornerstones of the Smart Object workflow. The first and most obvious is the RAW file. We have to understand why we want it, how we use it, and how to process RAW using the controls of Adobe Camera RAW. With the release of CS4 and Camera RAW 5.2, Adobe's Camera RAW gives you virtually every image control you need and the ability to go back to the RAW file and *construct* an image rather than chip away at it. This is the simple reason we want to work with Smart Objects. Mastering Camera RAW and understanding the potential of the RAW file is the first step to working with Smart Objects.

The second and equally important aspect of the Smart Object workflow is Layers. We first saw Layers using type in Photoshop, or when we moved from using standard Adjustment Tools to using Adjustment Layers. They opened up a new world of control and were the seed of the "non-destructive" workflow—a workflow that allows us to always go back to the image source. Adding the RAW file as a Smart Object to the Layer workflow takes this non-destructive workflow and turns it into a truly "constructive" workflow.

Finally, there are Masks. The Mask is linked to the Layer, and lets us create selections and controls over what part of the layer is used and how. The Layer Mask is an incredibly powerful yet intuitive tool that is inherently photographic in its use. It's something that feels natural, works smoothly within the parameters of the digital darkroom, and lets us use Smart Objects to their fullest potential.

PRIMER:

Non-Destructive Editing, The Digital Latent Image, and Metadata

To give you a better grasp on what non-destructive editing really is, I'll start with an analogy to sculpture: A sculptor who works in marble chips away at the stone; it is essentially a destructive process, but a very carefully controlled one. This is destructive editing.

When you adjust an image in Photoshop, you are chipping away at the data. You're never introducing new data, just as the sculptor cannot add more marble. Once you've made the edit, you've made the cut. This process is very similar to working in the traditional darkroom. You start with what is on the negative, and if it isn't in that negative, you just don't have it. You can darken it, lighten it, and crop it, but you can never add to it without bringing in a new negative.

Now consider a sculptor who works in clay. This artist can add and subtract material at will. In fact, clay sculptors often start with a basic shape and build up clay until the form they desire is there. They can also remove material and even go so far as to start over entirely. This is non-destructive editing (also referred to throughout this book as "additive" or "constructive" editing).

With the introduction of Camera RAW, Adobe began an interesting journey down a new road in image editing. Processing the RAW image file with Camera RAW allows you to essentially build the file using the basic data from the sensor, the digital "latent image." This is a major change in the very core of image editing.

The next revolutionary change came with the introduction of Smart Objects in CS2. Smart Objects are a container in the Layers palette, a way to wrap up and access the RAW data right in the Photoshop "darkroom." I can go right back to that digital latent image (the basic pixel-by-pixel data), and rebuild it right there in the layer. Layers, and image layers specifically, allow me to add data. Smart Objects allow me to rebuild that data. With CS3 came the added feature of Smart Filters, which allows me to apply a filter to a Smart Object and go back and re-edit the filter in that layer if necessary.

This is based on what is called "Metadata Editing." The metadata is a separate block of information attached to the image file. The metadata can deal with two aspects of the file data: It can tell you about the properties of the file (such as the time the image was shot, the ISO setting, the lens on the camera, etc.), and it can give instructions about the use and handling of the file. It is what I think of as the darkroom notes. This is where we can make a vast number of decisions about how the finished file will look, all without actually altering the information in the file itself. RAW files, interestingly, can only be handled with metadata editing—you can't alter that basic RAW pixel information, you can only alter the metadata that describes what you want done with the file. TIFFs and JPEGs in Photoshop, on the other hand, allow you to change the basic image information in the file. Using Layers allows you to at least retain the starting point of your edits as the background layer, but only when you get into Smart Objects can access the metadata in order to edit it and not the image file itself.

The Smart Object is a very small tip of the Adobe non-destructive editing iceberg, and understanding how it works, how to use it, and how it responds will point you down the path of maximizing your image processing to get every bit of quality out of your RAW files.

CHAPTER 1:

THE RAW DEAL

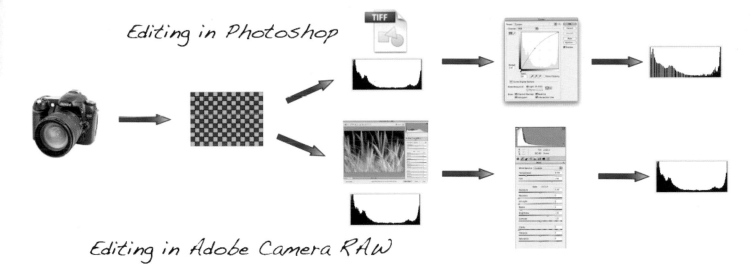

Editing in Photoshop

Editing in Adobe Camera RAW

Why Use Smart Objects?

Why work with Smart Objects? The direct answer to this question is, "Because you get to the RAW file quickly and easily." Of course, that answer then begs the question, "Why does that matter?"

Let's follow the progress of the image file through the system, from the camera to the final result—the image path. Light reflects from the subject and is directed to the sensor by the camera and lens. The sensor reads the values of light and creates the digital RAW file. This is what I like to refer to as the digital latent image, rather than the digital negative as some call it.

That file, processed as an image file in Photoshop, is "built" by Adobe Camera RAW. Once we get the image out of Camera RAW and into the main workspace in Photoshop, we have made all we can make out of the file.

Another useful analogy is the darkroom. When we get our negative into the darkroom, we have to make the best of it. We can't go back into the film processing and pull more shadow detail out. We can't go back to the camera and look for more color.

This is precisely where the RAW file differs, and why I call it the digital latent image rather than the digital negative. The RAW file data allows me get back to the light that hit the sensor; I can actually crawl back into the camera and pull out more detail, create different colors, or completely reinterpret how the RAW file was originally processed. The RAW file gives us huge amounts of information to work with.

Want proof? Look at the diagram above. What you have is the camera and the sensor and the two paths. The first path takes us to a Photoshop file as a TIFF; you can see a nice,

full histogram indicating lots of rich information. Then, we apply an adjustment curve. The resulting histogram is choppy and gapped (shown as white spaces in the black data). This will print with uneven transitions, banding, and a number of other unwanted results because this path erodes the image quality. The second path goes through the RAW processor; we get to the image, and once again, we have a nice, rich histogram. Instead of editing it with a Curves adjustment in Photoshop, I go back to the RAW file, use Camera RAW to rebuild the file, and make my adjustment there. The resulting histogram is full and rich.

Bayer Array: A Bayer array consists of alternating rows of red, green, and blue filters. The Bayer array contains two green filters, one red, and one blue filter; because the human eye is more sensitive to green light than to red or blue light, the second green filter measures luminance.

Luminance: The amount of light emitted in one direction from a surface. In a simple sense, luminance is brightness.

The RAW File

If you've read almost anything at all about digital capture, chances are you've seen the **Bayer Array** diagrams, and the basic RGB—or actually, RGGB—pixel "clusters."

I'd like to attempt a less technical description of what the RAW file is and how it's put together to really show what it's capable of.

The basic cluster of pixels is a group of red, green, and blue pixels, and a fourth pixel that is green. They act like little light meters, measuring the light and telling the camera how much of each primary color is focused on that tiny place. The fourth pixel is there not for color, but for brightness, or **luminance**. The set of three pixels translates the color correctly, and the fourth pixel determines how light or dark it needs to be.

Here's a great illustration, and it's found in none other than Apple's Color Picker application. Go to your Photoshop Preferences and pick the "General" tab. At the top of the tab is the "Color Picker" drop-down menu; select Apple. Then, when you click the Color Picker at the bottom of the toolbar, you get the window shown in **image A**.

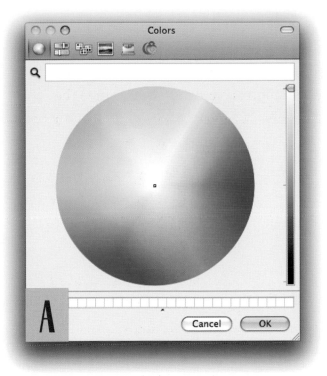

This is perfect. Here is the basic RGB color wheel, showing the **"primaries"**—red, green, and blue—as opposites. You get the RGB **"secondaries"** too, in the between-spaces, magenta, yellow, and cyan. Now for the cool part: Look to the far right at the white-to-black scale; this scale determines the luminance. Slide the tab to the mid-point and this is roughly what you get: **image B**. Pull it to the bottom of the scale and bingo—black (**image C**).

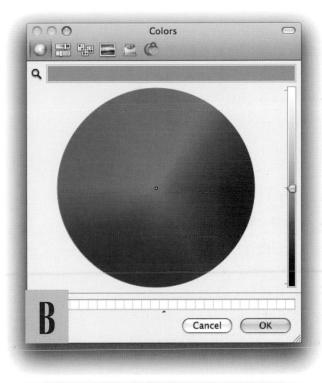

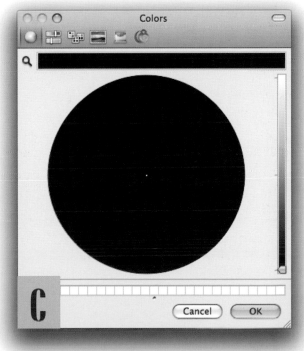

Primaries: Primary colors refer to the basic colors from which other hues are made. When discussing color generated from light, we use the "Additive Primaries" of Red, Green, and Blue. Various combinations of these three colors describe every other color.

Secondaries: Secondary colors are the colors generated by combining the Primaries. For example, looking at Additive Primaries of Red, Green, and Blue, the Additive Secondaries are what are found between. Yellow is between Red and Green, Cyan is between Green and Blue, and Magenta is between Blue and Red.

Using this color wheel, you can balance the values of red, green, and blue to make a color. Using the luminance slider, you can say how bright you want that color to be. This illustrates the exact formula that the camera and the sensor use to make color.

Describing a RAW file, however, is a little more complicated than that. The measurements from the camera sensor are generated as raw numbers, and we must make a few decisions to determine our colors in order for those measurements to be processed. That processing is where the power of a RAW file type comes from.

Contrast, Color & Scaling: The Three Steps to RAW Processing

The pixels on the sensor—each one of these four color-filtered light meters—do nothing more than regulate the amount of electricity flowing through them. Feed a pixel volts (say 12 volts for this example) and the pixel acts as a valve, letting the volts through according to how much light hits it. With a lot of light, the pixel's valve opens up and you get all 12 volts. If you get only a little light, the valve shuts down and allows maybe 1/100th of a volt. I'm making these numbers up for this example. The pixel voltage is actually measured in values of millivolts. This is all very nerdy, but hold on because we get a little nerdier. Those volts are not numbers that the computer, or a processor inside the camera, can use. To fit them into the framework of digital processing we have to make them, well, digital.

This is done inside the camera using the Analog to Digital Converter. If you want to really sound like a nerd—and who doesn't?—it's called an A/D converter. This takes the voltage reading and turns it into a number, a "bit" of information, for the processor to convert. The "bit depth" determines the scale of the numbers that the A/D converter is going to use. If you're going to an 8-bit conversion, then you're placing that voltage on a scale of 0 to 255. A small amount of light creates a very small voltage and will convert to a low number, like 10, on the 0-255 scale. The brightest light is 12 volts, will be generated into a value of 255, and everything in between will take its place on the scale. These processed numbers create the RAW file.

Bit depth: The number of bits of color data for each pixel in a digital image. A photographic-quality image needs 8 bits for each of the red, green, and blue RGB color channels, making an overall bit depth of 24. Each additional bit in a binary number doubles the number of possibilities. By the time you have a 16-bit sequence, there are 65,536 possible levels.

8-bit conversion: When you convert a RAW file using a RAW processor, you have the choice of converting it to an RGB file that is either an 8-bit file or a 16-bit file. In an 8-bit file you have 256 numerical steps of tone in each color channel (R, G, and B); 0 represents black and 255 represents white. (A 16-bit conversion has 65,536 steps for each of the three channels.) Every number from 0 to 255 represents a different tone; the color combinations possible from an 8-bit RAW file conversion are 255 x 255 x 255, for a total of 16,581,375.

Tricks and Tips

A brief word about "tricks and tips." I seriously can't stand 'em. No, seriously.

Tricks and tips are more about "see what I can do" than creating a solid, professional working process. (I'm even having issues with the word "workflow" lately, because it's become such a catchphrase.)

There is a place for learning things that can speed and simplify a coherent process when appropriately integrated, and this is what we need to focus on. Start by building a framework for your process, and as you've probably figured out, the framework I've decided is the best for me is the Layers/Masks strategy. I am fairly strident about it now; as the Smart Object workflow shows, it is a basic structure that is not destructive, is as archival as possible, and is so flexible that I have yet to find an application where I can't use it.

Frequently, the "tips and tricks" approach does just the opposite—it sends you down a rabbit hole that forces you to abandon a good, well thought-out, and proven strategy for the sake of what feels like a gimmick.

Show me a professional workflow, and then give me something that can make it better. Tricks are for kids.

Now think about what we have. We have four numbers for each pixel. Three of them measure the pixel's color, and one of them measures the pixel's brightness. We place them on a somewhat arbitrary scale to make them into numbers the computer can work with. Up to now we don't have much of a picture; nothing you'd probably recognize. Three things must happen to make this into something like a picture. First, we must decide what values are black, what values are white, and map the values in between. This determines the image contrast, and is called the Contrast Curve.

Second, you have to make some sense out of these colors. This is done by designating the values in the image that are neutral and mapping the colors around that point, and is accomplished with the "White Balance" setting (in your camera or in Camera RAW), and the camera profile chosen in Camera RAW. This determines the image color.

Finally, we must decide the image scale. We are starting out with four values; the computer processes those values and makes one "virtual" pixel—one pixel constructed with all the important information. Actually, here you can make a pretty interesting decision. You can decide to make one pixel out of the four, or you can try to eek out as much information as possible (**interpolate**) and potentially make four pixels. Look back at the Bayer Array shot again

Interpolate: A statistical method of projecting data between known values. In digital photography, to interpolate resolution is to build new pixels based on the values of neighboring pixels. (The mathematical opposite of interpolate is extrapolation, or projecting a value based on an established trend.)

(image A). You have group after group of these four-pixel clusters, overlapping in some really handy ways (that is, if you're into math). You can decide to make the final RGB image bigger, or conversely, smaller, using the RAW data. Bundled with that decision is a "sharpening" decision, too. It is where you determine how much or how little you want to emphasize the color edges, or the tonal differences between neighboring pixels. That's it—scaling and sharpening.

I'm going to paraphrase a good friend of mine, Bruce Radl of Mosaic Imaging, in his explanation of this. This technique of constructing (demosaicing) a RAW file is the process of taking an image made up of separate R, G, and B pixels, and making a file in which each pixel has an R, G, and B value. In other words, we start with red, green, and blue pixels on the sensor.

When we get to Photoshop, each pixel now has a red, green, and blue value, or an RGB value. The RAW process is where we do that.

The conclusion to this is the most empowering point of the whole discussion. Processing the RAW file—bringing it from the red, green, blue and luminance values, into an RGB state in Photoshop—is a process of building; a construction process. We take the bricks and mortar of the sensor and build a house from it. Smart Objects allow you access, to go back and rebuild that house in any way you see fit.

Demosaicing: The process of translating primary colors into a final image that contains full color information with each pixel.

Histogram: A two-dimensional graph showing the brightness range of an image. Histograms plot brightness along the horizontal axis and number of pixels at that brightness level along the vertical, and are useful for determining if an image is likely to be under or overexposed.

Examples: Watch the Histogram

This example shows pretty clearly why this discussion is important. First, I open a file using normal settings. I'm going to open my "Histogram" window so we can see exactly what the file is doing.

I've put a Curve adjustment on this image to make the midtones a little brighter (**example 1**). Now look at the Histogram. See the white gaps (**example 2**)? That is exactly what I'm talking about. Those are gaps, holes between the pixel values in our image. This approach takes the information we have in the image file and stretches it to accommodate the edit. We've not added data; we've merely massaged the data we have. This is not a process of building; it's a process of moving existing information around. We've spread our pizza dough out too thin.

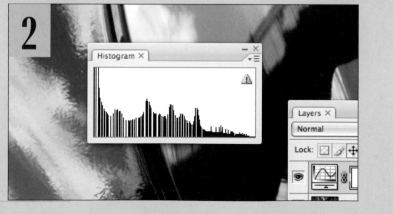

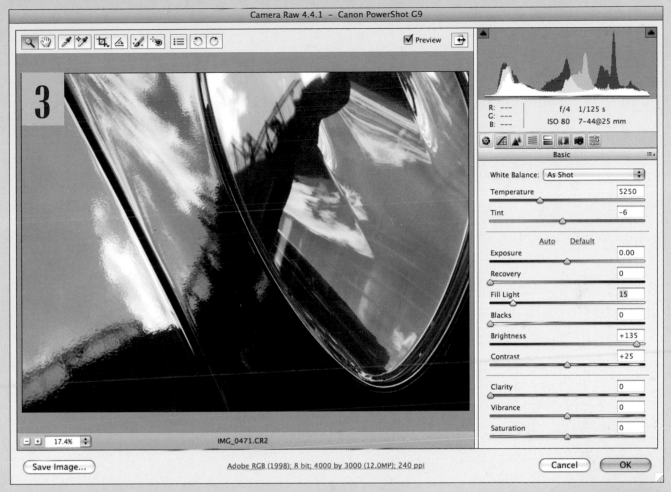

Camera Raw 4.4.1 – Canon PowerShot G9

IMG_0471.CR2

Adobe RGB (1998); 8 bit; 4000 by 3000 (12.0MP); 240 ppi

Basic

White Balance: As Shot
Temperature 5250
Tint –6

Auto Default
Exposure 0.00
Recovery 0
Fill Light 15
Blacks 0
Brightness +135
Contrast +25
Clarity 0
Vibrance 0
Saturation 0

Now, let's go in and make the same editing move with the RAW dialog (example 3). I re-open the Smart Object and lighten up the midtones using the Brightness slider, the Shadows, and even a bit of the Fill Light control. Now look at the histogram of the re-processed image (example 4). No white gaps! The interesting thing is you can see that the histogram shape is pretty much the same; that means I've made the same "moves" and matched the two adjustments pretty well. It's just that the Smart Object path is full and clean. We've added enough pizza dough to get the thing to where we need it.

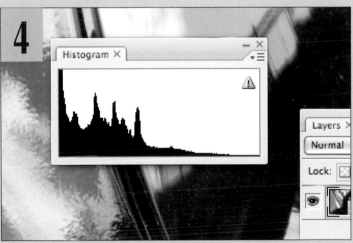

*B*it depth, to review, is the number of bits of color data for each pixel in a digital image.

To start, I'd like to bury the terms "24-bit" and "48-bit," since what they refer to are just the expanded 8- and 16-bits from the three RGB channels. (If you take a 16 bit-per-channel file, and multiply it by three for its three channels, then you have 48 bits. I guess that sounds more impressive for marketing purposes.)

I'm going to use this nice little program on the Mac to help show this. It is called Digital Color Meter, and you can find it in Applications>Utilities.

Here's how it works: Place the cursor on any color on your screen. Here, I've placed it on the little red button on the upper left corner (*image A*). Depending on what "readout" you've selected, it gives you the actual RGB color numbers the monitor is using. The dropdown menu supplies quite a few options, but for this example I'm selecting "RGB As Actual Value, 8-bit" (*image B*).

When I place my cursor on a white patch, I get 255, 255, and 255. Every color in an 8-bit RGB image—every color represented in digital form, for that matter—is made up of three channels in 256 individual steps, from 0 to 255. (Remember: 0, 0, 0 is a color, too.) For example, 255, 255, 255 is a different color than 255, 255, 254. (There is no such thing as 255, 255, 254.5.)

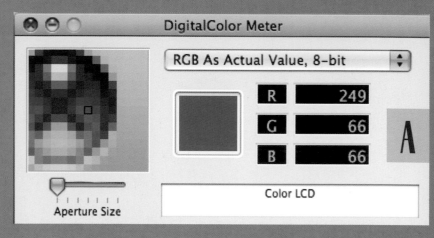

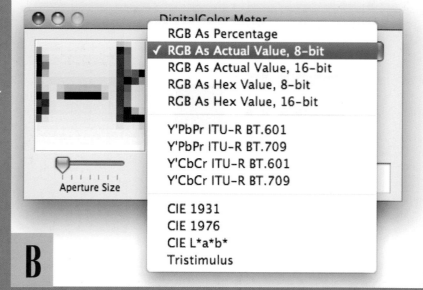

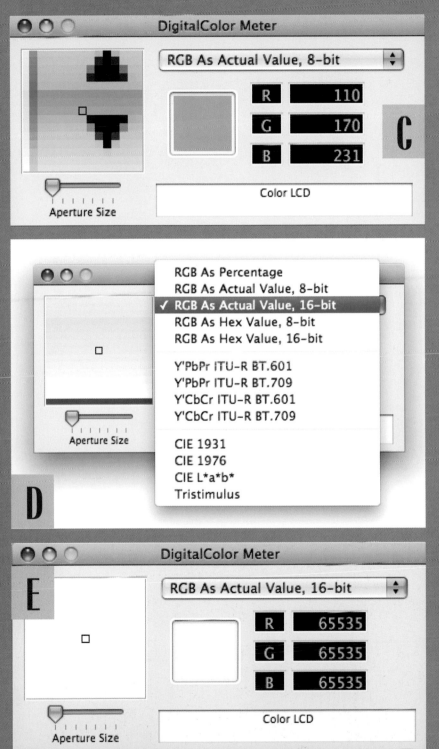

Since every color is a simple combination of these three channels, that multiplies out to millions of colors when you work with 255 values for each channel. To be precise, 16,777,216 colors. Let's look at this shade of blue (*image C*). Its values are reading as 110, 170, 231.

Now, pull down "RGB As Actual Value, 16-bit" (*image D*) and put the cursor on the white again. Look at that number: 65,535; 65,535; 65,535 (*image E*). We now have 65,535 values between black and white, and 65,535 shades of red, green, and blue that we can combine to create a color. This gives us billions and billions of possible colors. Actually, it gives us 281,474,976,710,656 possible colors. Trillions.

Let's look back at our blue patch now (*image F*). We now have 28,270; 43,690; 59,367. That is going to be a different color than 28,270; 43,690; 59,366. 16-bit files give you more color options—more crayons in the box.

Let's bring this back to the Smart Object workflow. The general advice is to use 16-bit files for the best quality, simply because you have so many colors to work with. By the time you edit 8-bit files in a conventional way, you will probably have gaps in your histogram. Here's an example (*image G*). In this example I purposely clipped the highlights. Because I am pushing the data to fit the new adjustment, I stretched the file to the point of creating gaps between my steps of color.

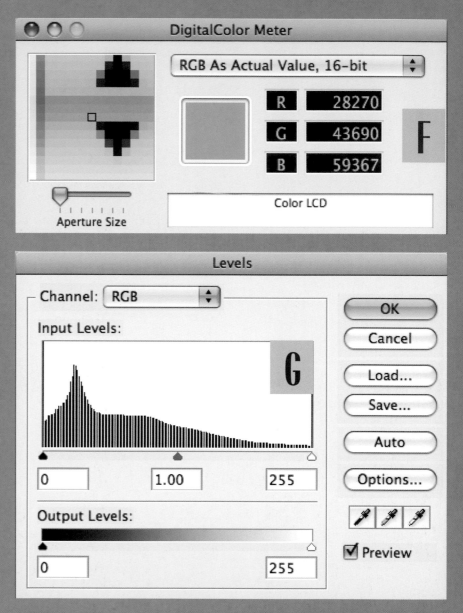

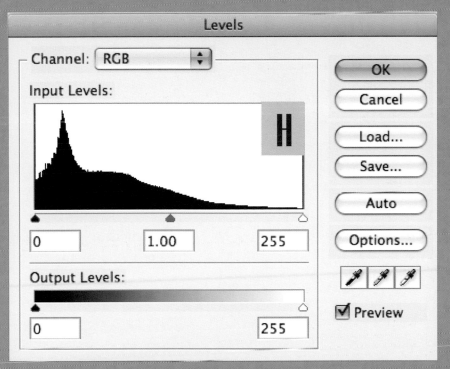

Here's the same adjustment made to a 16-bit file (*image H*). There are no holes in the histogram because I am working with so many colors.

This is good advice for a standard, destructive editing workflow in Photoshop; essentially you're giving yourself enough colors to be able to throw some out without seeing the gaps. However, there are a couple of problems. For one, unless you're using a camera with a large sensor, you're not really capturing in 16-bit so you aren't starting with all that color; you're just trying to re-map 12- or 14-bit files out to 16-bit. Second, you're making a huge file, especially if you're working with multiple layers of Smart Objects. Remember, each Smart Object adds the complete "weight" of the file. Even my little Canon G9 comes out to more than 30MB layers in 16-bit processing.

Since you're working with a constructive workflow by building layers of RAW files in rather than stretching existing files out, my advice is to stay in 8-bit. It's faster and more accurate, and the 16-bit overhead is just not necessary.

*H*ere's a quick rundown on how to set up color management in Photoshop for a good, high quality color managed workflow for photography. There are only a few things I'm really concerned with here. First is the RGB working color space, because that is my playing field; it sets the rules that Photoshop will use when working colors. Second are my policies—will Photoshop keep the file intact, and let me know when there's a problem? Lastly are my conversion methods and how the color is translated.

Go to Edit>Color Settings (*image A*) and you'll see this menu (*image B*). This is the default setup.

Start by selecting "More Options," and you'll get this bigger menu (*image C*). In order to get to where you need to be, select *North American Prepress 2* in the dropdown menu (*image D*). This takes you to *AdobeRGB 1998* for your RGB color space and sets up some nice conservative color policies such as "Preserve Embedded Profiles" and "Ask When Opening for mismatches and missing profiles." One last thing is to set the Conversion Options to Perceptual Intent (*image E*). Your menu should look like this (*image F*).

Finally, save the setting. Hit "Save," and name the setting (image G).

There you have it (image H). You're working in the standard color space for the highest quality work, AdobeRGB, preserving the color information in the files. You'll get a warning and a question before Photoshop lets you open a file that isn't set up the way you're used to working (image I). Generally, with a missing profile or a profile mismatch I'll select "Convert document's color to the working space."

Finally, the method Photoshop uses to make any conversions will be Perceptual Intent, which keeps the relationships— the "spacing" of the colors when it has to remap them to fit a smaller space.

Are you interested in reading more about this stuff? Check out my book, Color Pipeline, for a detailed explanation of Color Management and the path of color through the digital photography process.

CHAPTER 2:

ADOBE CAMERA RAW

The Definitive Camera RAW Primer

It occurs to me that if I ask you to forsake all other adjustment methods in Photoshop for Adobe Camera RAW, it would be helpful to tell you about making adjustments there. I've decided to do one better. I'd like to make this "The Everything You Need to Know" guide, and go through the essential features of Camera RAW, the most useful features, and others that are just handy.

I'm going to go through these features and give them little ratings as to how I feel they play into the Smart Object process. Five star features (★★★★★) are essential, three star features are important or helpful, and no star features are superfluous.

In our RAW process, we are dealing with three basic functions—color, contrast, and scaling. As I'm famous for my analogies, here is my "rental car" analogy: When you rent a car, you take a minute to acquaint yourself with the basic controls like the steering wheel, the brakes, and the gas pedal. After that you may look for your favorites—the stereo system, the headlights, and maybe the windshield wipers. RAW processors are the same thing. We're looking for the basic controls, and then figuring out the extras. Some extras we may need (like a satellite navigation system) and some we may not (heated seats in the summer). Let's tear into Adobe Camera RAW and separate the wheat from the chaff.

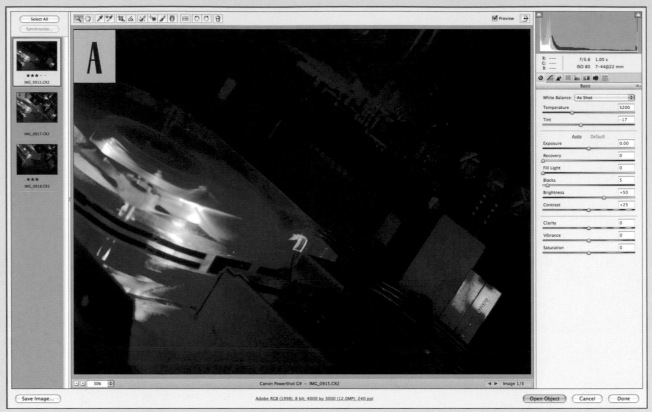

Here is the main Camera RAW workspace. I have three open images; I selected these three images in Adobe Bridge and opened all of them at once in Camera RAW (image A). This is the main image window, showing the preview for the shot I've selected in the "filmstrip" on the left (image B). The toolbar is at the top of the window (image C).

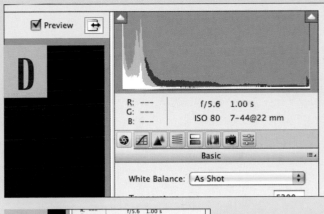

In the upper right corner is what I call the "info" area (image D), and below that are the tabs used to make adjustments to the image (image E). Along the bottom are the buttons, with your "Workflow Options" in the middle, which looks like a webpage link (image F). We'll start with the toolbar and work our way around the window.

> **NOTE:** Keyboard shortcuts are shown in red and in the following style: <keyboard shortcut here>.

Zoom Tool

Toolbar ★★★★★

Zoom Tool: The first tool is the Zoom tool. You can quickly access this tool by hitting <Z>. The zoom tool performs just like in Photoshop's main workspace: <Command +> zooms in, <Command –> zooms out, and <Command 0> fits the image to the window. The lower left corner gives you the current and standard zoom percentages. Take a look at the Geekzone on the next page to see why setting the display resolution is so important, especially when using the Zoom tool.

I always suggest you use Unsharp Mask when the image is set to the final print size, and I recommend you turn on the rulers (View>Rulers) so you can see if Photoshop is actually displaying the image at the correct size. There is a way to set up Photoshop so you can be sure.

It's a well-kept secret that, although the display resolution is generally considered to be 72 ppi (pixels per inch), it is never that number. For some reason, 72 ppi was the agreed common denominator for standard display resolution. Because of that, Photoshop defaults to the 72 ppi display resolution, and so it never gets the actual "Print Size" right.

The first step is to figure out what your actual display resolution is. The easiest way is to first measure at least one dimension, physically, with a ruler. The width of my iMac is 17 inches (43.2 cm). Go into your System Preferences (*image A*) and select Displays. Look at your resolution. I have 1680 x 1050 selected (*image B*), so I'm going to go with 1680 pixels for 17 inches (43.2 cm). With a little simple division I get 98.82 pixels per inch.

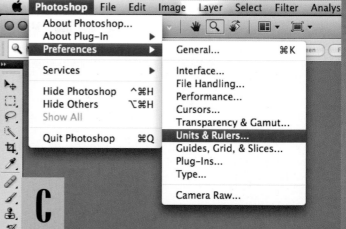

Armed with this information, I now go to Photoshop>Preferences>Units and Rulers (*image C*), and set the Screen

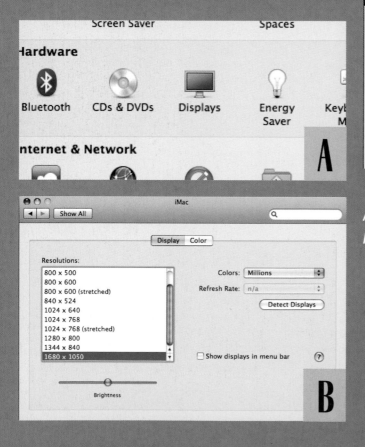

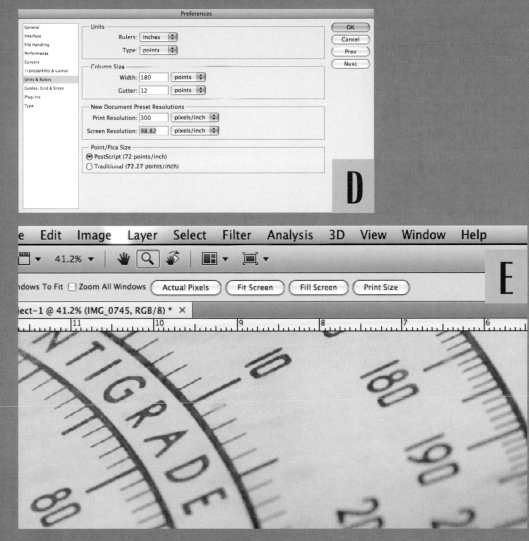

Resolution to my 98.82 (*image D*). I hit OK; now when I open
my file, show the rulers, and ask the Zoom to display at Print
Size, I get exactly that (*image E*). One inch displayed on the
screen is one inch.

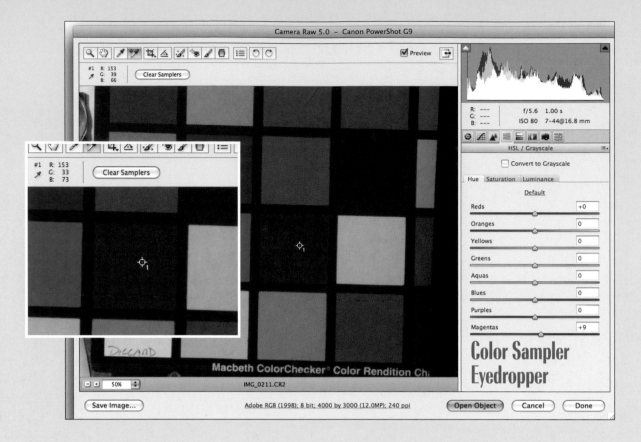

Color Sampler
Eyedropper

Hand Tool ★★★★★:

Next is the Hand tool <H>. As in Photoshop, you can access the hand tool by holding the space bar; the hand tool moves the image within the Preview window.

Eyedroppers★★★:

The next tools are the two eyedroppers; and the left icon is the White Balance eyedropper tool <I>. This forces whatever value you click on to become neutral. For example, if you're shooting a ColorChecker chart and you notice the color is shifting to red, the RGB numbers may read 140, 120, 120 on the middle gray patch. Select the White Balance eyedropper and click on that

patch, and the tool makes the three channels equal somewhere in the middle of the scale. What you'll get is something like 127, 127, 127, or perfect neutral gray.

The other eyedropper, the Color Sampler tool <S>, gives the RGB information for the exact spot you click and retains that spot's location. Bruce Fraser, in *Real World Camera RAW* goes through the process of shooting a ColorChecker chart and adjusts each patch to match the "target" values perfectly. This is the tool you'd use to do that. Select this tool and click on each color patch of the target; it gives you RGB readouts for each one which you then monitor as you make your adjustments.

Crop Tool ★★★: Now for the Crop tool <**C**>. If I simply choose this tool, I'll get the conventional crop tool (when you click and drag, the tool uses only the selected area when it processes the file). If I click and hold this tool, I get this window (**crop 1**). This expanded crop tool gives me several preset ratios or a custom option. If I select "Custom," I can set the tool to crop specifically to the dimensions I've designated. In this example I've set it to 5 x 7 inches (12.7 x 17.8 cm) (**crop 2**). This is a very useful tool in speed-processing RAW files for a certain purpose, but not as useful in the Smart Object workflow. We'll talk about why this is the case a little later, but suffice to say I prefer to do my cropping in the main Photoshop workspace. Your cropping information is available through the "Workspace" link at the bottom of the window (**crop 3**); to clear the selected crop simply hit escape <**esc**>.

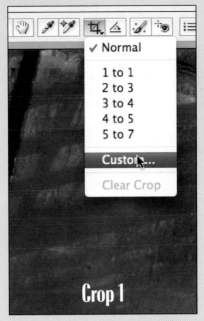

Crop 1

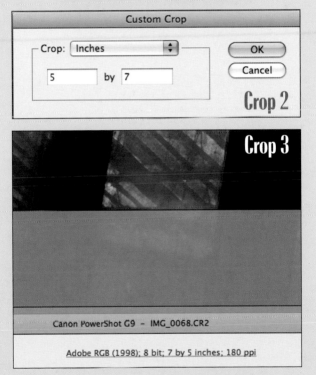

Crop 2

Crop 3

Canon PowerShot G9 – IMG_0068.CR2

Adobe RGB (1998); 8 bit; 7 by 5 inches; 180 ppi

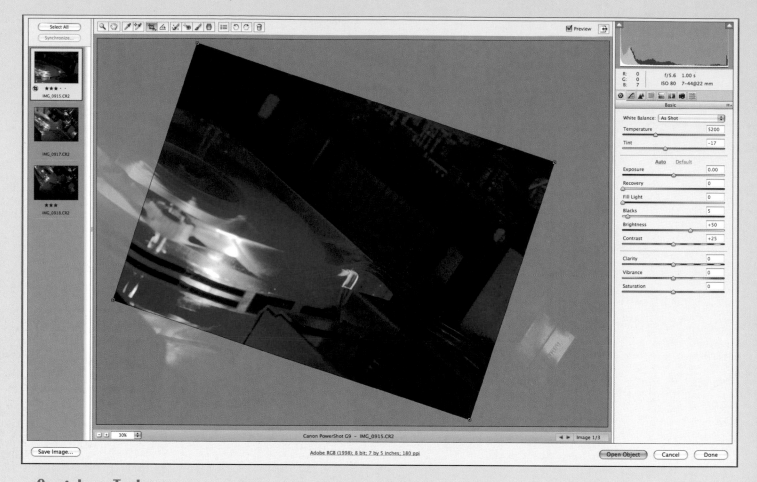

Straighten Tool ★★★: Beside the crop tool is the Straighten tool <A>. This tool invokes the crop tool, but allows you to click and drag along a line to set a baseline for the crop. I actually use this a bit more, just because, when shooting elevations of buildings (something I love to do), I can correct tilting in the camera quickly.

Retouch Tool ★★★★: The Retouch tool gives us the familiar Heal and Clone brushes, but the controls are slightly different. I can select my radius, and I can alter where I'm sampling from and to, with the "overlay" (retouch 1). Here's what this looks like. I can either adjust the radius with the slider, or simply grab the edges of the circles and drag them out or in.

I can also click and drag the inside of the circles to move them around. The green circle is the source and the red circle is the target.

Red Eye Removal Tool: The Red Eye Removal tool <E> is something I find…um…well… silly. Sorry. Nevertheless, here it is, so have fun. (I always liked those demonic images of my dog with red pupils. But maybe that is just me.)

retouch 1

GEEK ZONE: CAMERA RAW CS4: THE ADJUSTMENT BRUSH

*T*he release of CS4 includes a few nice enhancements in Camera RAW. Perhaps one of the coolest pair of features is the Adjustment Brush and the Gradient Filter (*image A*).

The Adjustment brush opens up a new control panel (*image B*). It's operation is pretty simple; decide what you want to do, and click/drag the area of the image you want to do it to. In this example, I'm making an exposure adjustment, and I've clicked one spot to apply it (*image C*). It gives us a little icon overlay—a kind of pushpin—that shows where we applied the adjustment. There are a great array of tools you can apply this way, giving you very fine control over the tonal values, the opacity of the adjustment, the size, and even the feathering of an adjustment.

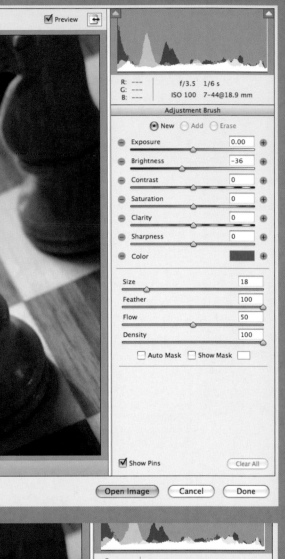

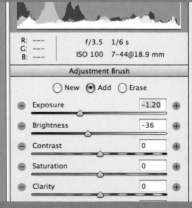

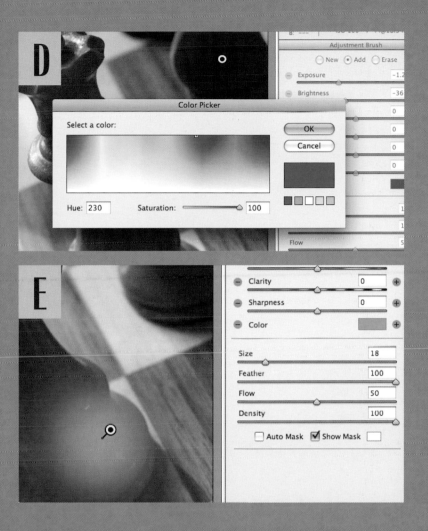

You can also make color corrections. If you click the little color patch you'll get this window (*image D*), which allows you to pick virtually any color and its saturation. When you apply this to the image, it shifts the image colors over to the colors you've selected—in this case blue. This allows me to make spot color corrections in the RAW process without having to make a new layer and mask it. (Well, technically we are making a mask, just not in our layer workflow.)

Click the selection on the bottom, "Show Mask" (*image E*). Now you can actually see the shape and location of the adjustment. It also gives us a peek under the hood to see how Camera RAW is controls the selections. The fact that you are simply using a mask is pretty interesting, and actually kind of exciting; it brings us back to the basic tools we know and love, and we can begin to understand exactly what we're doing.

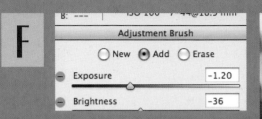

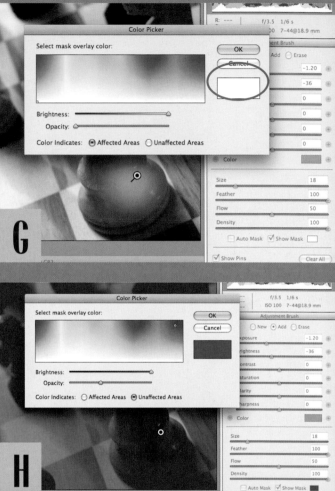

Back to the top of the menu: We have the very helpful New, Add, and Erase selections (*image F*). Think of the Adjustment brush as a masked feature and this selection makes a lot of sense. Just as in layers, you can make new masks, add to them (paint white), and erase from them (paint black) to control the areas of the Adjustment brush. Go back to the "Show Mask" control and click the white rectangle to the right (*image G*); here you can set the color and appearance of the mask. I like the old rubylith mask from my silkscreen and prepress days, so in this example I've changed it to red and selected "Unaffected Areas," which helps me keep better track of what I'm doing (*image H*).

This is great in theory, but can get kind of dangerous in practice. If you're making a ton of corrections here, you end up with an image and a whole bunch of little pins, and it's not really easy to see what you did and where. It's great for a quick touch—to darken a highlight or open a shadow—for an image you're making simple corrections to. If you're doing a lot of work on an image, I'd advise to make separate Smart Object layers and label them to leave yourself better notes—a better trail of breadcrumbs.

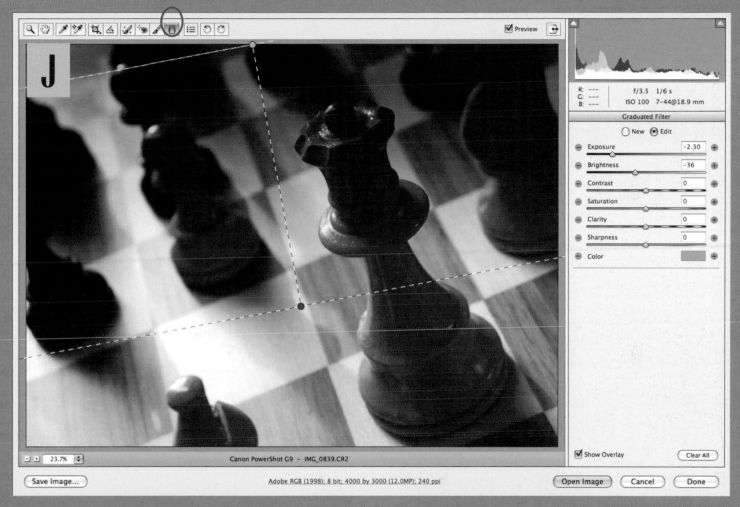

The other adjustment and masking feature we get is the Gradient Tool, right next to the Adjustment brush (*image I*). This is really nothing but a big, rectangular Adjustment brush that makes a nice even gradient from no adjustment to a full adjustment. Just click where you want it to start and where you want it to end (*image J*). You can go back and fine-tune this with the Adjustment brush pretty easily, but there's no way to see the combined effects on the mask. Yet.

Camera RAW Preferences Button ★★★★☆:

Nicely nestled in there with the red-eye tool is the Camera RAW Preferences button <Command+K>. This is the accompanying window, and for the most part I leave that at the defaults. It's nice to know where to find it, though.

Rotate Buttons

★★★★★: Next you have your simple Rotate buttons, which should be pretty self-explanatory.

Then there is the Trash button. Hit the Trash button and the image is marked for deletion with a small red "X" in the upper left corner. Hit the Trash button again and the image is deselected. And yes, it will move that RAW file into the Trash. Be very careful with this tool.

Variations on the Tools

Combinations of a few keys give you some access to other menus for the frequently used tools. Here is a quick rundown.

Zoom Tool plus:

<Control>: opens a Zoom presets dropdown menu

<Option>: zoom out

<Command>: Hand tool

Hand Tool plus:

<Command>: zoom in

White Balance Eyedropper plus:

<Control>: opens a White Balance presets dropdown menu (Daylight, Tungsten, etc)

<Option>: zoom out.

Crop Tool plus:

<Control>: opens a Crop presets dropdown menu

<Command>: Straighten tool

Retouch Tool plus:

<Command>: clears Retouch

The Info Window
Preview and Full Screen Buttons

★★★★★: Look at the top right corner of the Camera RAW window. The first thing we see is the Preview and the Full Screen button. Preview allows you to toggle between showing your adjustments or not, and the Full Screen view lets you quickly maximize the workspace on your monitor.

Histogram ★★★★★: Now, for the most important tool of digital imaging—the Histogram. I've activated my Shadow Clipping Warning <U> shown as a blue gamut warning, and my Highlight Clipping Warning <O>, as the red gamut warning. These are the two little arrows at the top of the Histogram pane, at the black point (far left) and white point (far right). We'll get more into this later.

You'll also notice you get your RGB info for wherever your cursor is, and some basic camera information: f/stop, shutter speed, ISO, and lens zoom.

Clipping Warning: The clipping warning alerts the photographer to highlights that are out gamut—the range of values that the sensor can record.

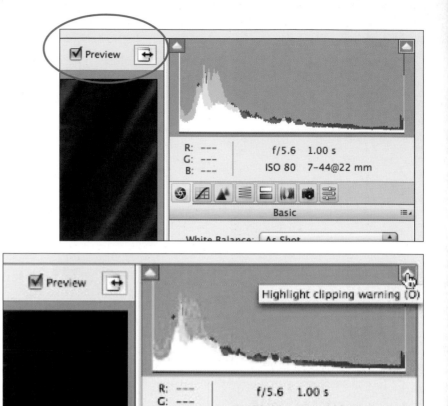

Buttons and Workflow Options

Save Image Button ★★★: I'm going to really go into depth about the adjustment tabs, so let's skip over that for now and go right to the buttons. At the bottom far left of the window is the

Save Image button (save 1). This gets you to this screen (save 2). This allows you to save images directly from Camera RAW into a processed format like TIFF or JPEG—a great move with the batch processing method, but not too handy in a Smart Object workflow. (You can also save these files as the DNG format. See page 258 for more on DNG.)

Open Object, Cancel, and Done Buttons

★★★★★: At the other end is Open Object (or Image), Cancel (which changes to Reset if you hold <Option>), and Done. The Done button applies your edits to the image file's XMP data (refer to page 128), and the Open button opens the image in the main Photoshop workspace.

Workflow Options Link ★★★★★: Finally, in the bottom center of the window is what looks like a web link. Click it and you get the Workflow Options. This is where you tell Camera RAW how you want it to color-manage the file; that is, what Working Color Space you're looking for, the bit-depth, and the image size (refer to Color, Contrast & Scaling on page 23). Finally you have the Resolution. This is simply the "Document Resolution" target for Photoshop. It does not change the size, (the Size selection does that); it simply changes the way the size is displayed in the document. There is more on this on page 40, but simply put, if you set the document resolution to 180 and open the image, your Image Size in Photoshop will say 180 in the Document Resolution window.

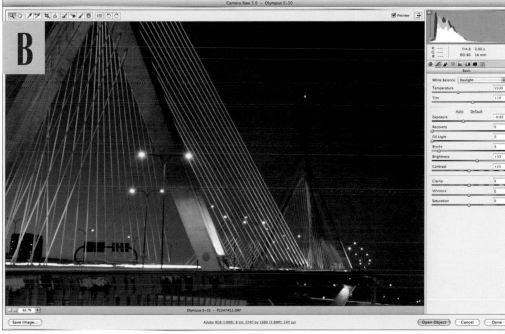

The first example (**image A**) is "As Shot," which is reading my camera tags (I set my camera for Daylight). Next, just for laughs, I changed the White Balance to Daylight (**image B**). There is a subtle difference between what Camera RAW thinks a daylight balance should be and what my camera thinks.

Now I switch it to Tungsten and Camera RAW balances the image color for what it thinks to be light bulbs. Because it was not—it was closer to daylight, which is much bluer than light bulbs—everything goes blue (**image C**). This is actually a very cool trick for shooting architecture at night.

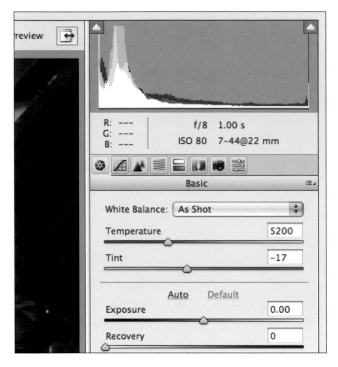

Color Adjustments

White Balance ★★★★★: As you may suspect, White Balance is your main color control. Remember the White Balance eyedropper in the Toolbar? Your first step in building image color is to decide where your neutral is—the core of all the decisions Camera RAW makes when mapping out the information from the sensor. You can do that with the presets in your camera, the presets in the White Balance pulldown, or with the eyedropper (but only if you have an accurate neutral patch in your image to click on).

Temperature: The Temperature slider moves the basic colors from blue to amber. (This comes from the "Color Temperature" rating that some of us were familiar with when shooting film; with today's digital cameras, we set the White Balance preset or custom setting.) Daylight film has a color temperature of around 5000 **degrees Kelvin** (5000K); Tungsten is around 3700 degrees Kelvin. Don't let this frustrate you if you're not used to thinking about color temperature when you are shooting; just remember that blue is to the left and amber is to the right.

Tint: The Tint slider is what we used to call "cc," for filtering our cameras to match fluorescent lights. This slider goes from green to magenta. Between this and the Temperature slider, you can make just about any change to the overall image color, and put it wherever you choose. I'm going to go through some basic settings so you can see the effect. Look both at the histograms and the position of the sliders as I change the White Balance preset, and then make my own.

Degrees Kelvin: An absolute scale of temperature most often used in the Physical Sciences, Kelvin describes temperature based on atomic movement. 0 degrees K, for example, describes the theoretical condition where there is virtually no atomic movement, and is called "Absolute Zero." In photography, it is used to describe the temperature of a light source and translates to the color that light appears to the eye. Daylight, for example, is 5000 degrees K.

This is very useful in a Smart Object workflow, especially if you're doing High Dynamic Range work. I can get the colors lined up exactly and apply them to a handful of images before I open them. I can then work them individually, but the heavy lifting is done.

High Dynamic Range: Also called HDR, High Dynamic Range photography is a technique allowing the photographer to capture and manipulate multiple images with light value ranges far beyond what a single image is capable of recording. The technique uses bracketed exposures and merging techniques to create a single image. Very often specific HDR software is used to control and merge these bracketed exposures.

Hint: Pushing the <Option> button and clicking the Select All button switches the button to "Select Rated," allowing you to sort out the files you've given ratings to or not. <Option> and clicking the Synchronize button lets you sync everything and bypass the dialog window, applying the sync settings that were last used.

Now that you are feeling all warm and fuzzy about the Camera RAW window, let's go into each of the Adjustment tabs, one by one.

Camera RAW Adjustment Tabs
The Basic Tab

I suspect this tab gets its name not because the adjustments are for beginning users, but because these are the basic starting point adjustments for working with the image. Think back to the Color, Contrast & Scaling section. The Basic tab handles two out of the three, and the more advanced features just fine-tune those adjustments. I'm going to go through each of these and rate the features according to what I believe to be useful, but I'm also going to address which part of Color, Contrast & Scaling they affect.

Keep an eye on the Histogram as we plug through these adjustments. This is one of the nicest thing about Camera RAW—the histogram reflects every editing move you make and how it's going to change the way the tonal values are built. If you know what your printer is going to do with those values, then you really have a powerful tool, but that's the subject of another book. (*RAW Pipeline*, to be exact.)

Open in Photoshop as Smart Object

★★★★★: This is the most important item of all—the Open in Photoshop as Smart Object box. This sets Camera RAW up to open everything as a Smart Object, and changes the Open Image button (bottom right) to Open Object.

Filmstrip or Thumbnails

★★★★: One more thing before we get into the adjustments. The filmstrip, or thumbnails, or whatever you want to call it. This is a great tool for applying settings to a group of images. Hit the Select All button and then hit Synchronize (filmstrip 1). This gives you this dialog (filmstrip 2). The Synchronize button allows you to apply any or all of the settings you've made to the active image (the image shown in the preview) to any or all of the images in your thumbnails. It's extremely powerful. There are a ton of presets shown, and you can also create your own with the Custom Subset.

Have you ever wondered how photographers get such deep blue-black skies and nice, clean white lights inside the house? In the digital age, they process the file with a tungsten white balance.

Finally, I took my White Balance eyedropper and clicked on a spot on the gray concrete bridge (image D). This is totally random. Sometimes it works great, but the point is that you're telling Camera RAW, "Here is the point that I want you to build the color around." I'll look at the image, pick out a spot that might work, and try it. If it doesn't work, I try another. (If I was in the studio and wanted a perfect neutral color to base this adjustment on, I would shoot a ColorChecker chart and click a gray patch.)

Contrast Adjustments

Highlight Clip: An adjustment that allows you to move the highest values on the histogram to pure white.

The next group of sliders all accomplish the same goal: They give you controls to adjust the Contrast. I'm going to use the term "curve" here, because the curve is the basic mode for controlling how tones are handled from dark to light. To better understand the effects of the contrast curve, watch the histogram. Let's go through each one, but I'm not going strictly in the order they are arranged in this tab. Bear with me, it's going to make sense.

Exposure ★★★★: Exposure is otherwise known as the **highlight clip**. You're simply moving the brightest point in the image up and down on the histogram. If the brightest point falls short of the pure white point (255, the far right margin), it is going to be darker than white. If it gets clipped—or pushed beyond that margin—it will be pure white with no detail. Take a look at these three settings, and the resulting histogram. The first image is at the default setting of 0 (**image A**). Then

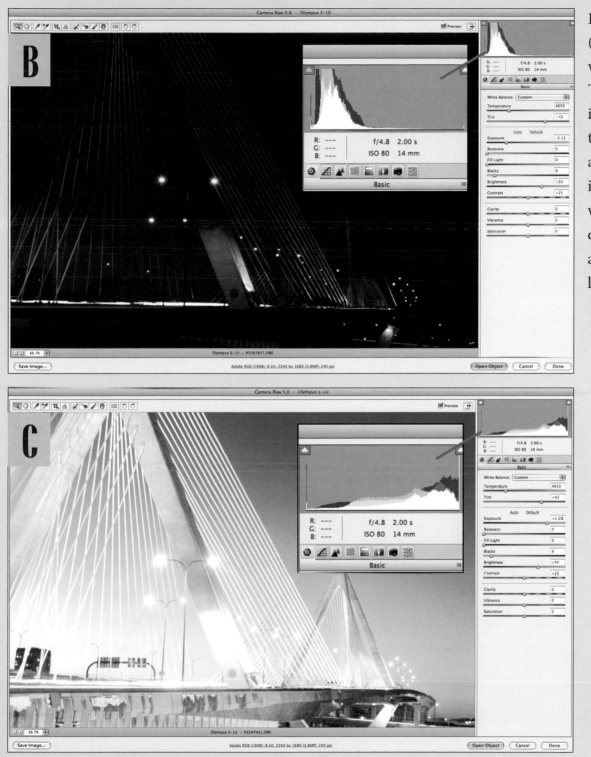

I slid it way down (image B), and then way up (image C). The only thing that is really changing is the highlight point and where I'm placing it. The rest of the way the histogram changes is just to adapt to that highlight clip.

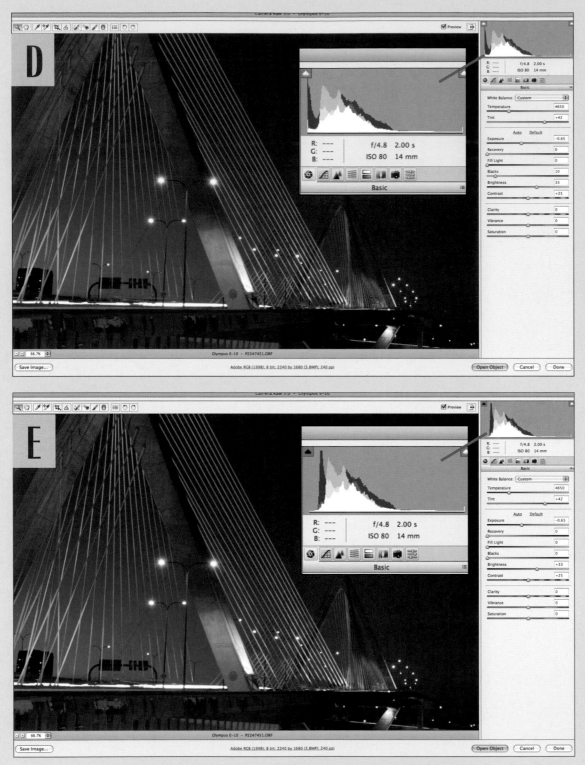

Blacks ★★★★:
Skip down to the Blacks slider. This is the shadow clip. Just like the highlight clip in Exposure, this slider gives us control over where the black point falls on the histogram. Here is the "normal" setting (image D). Here is the setting at 0 (image E). Remember to watch the histogram.

Brightness
★★★★★: Go to the Brightness slider and watch the histogram. If I slide the Brightness slider down, it pushes all the middle values—the medium light to medium dark

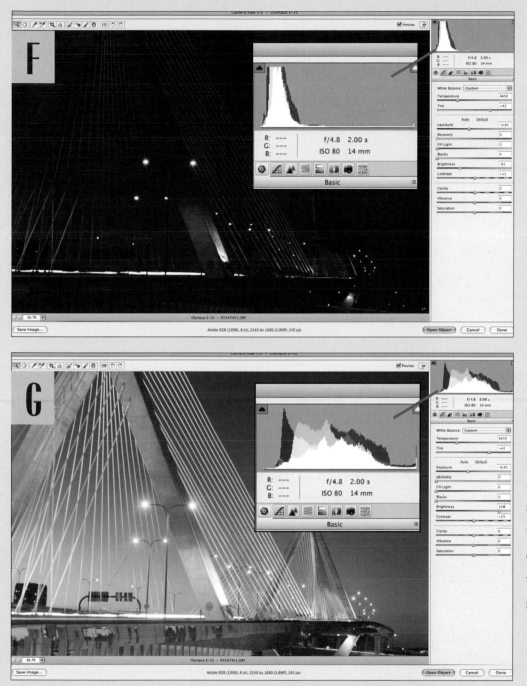

tones—down to dark (image **F**). I move the slider up and the histogram shape moves up towards the lighter tones (image **G**). This does not really touch the black or white points I've set in Blacks and Exposure; it moves the tones around within those points.

If this histogram talk confuses you, try to think of the histogram as the print, or the output—it is set in stone. The left border is black and the right is white. The histogram itself is a graph or picture of the tones in your image, and how the image is going to show up once you "output" it. You can push the tones around like pizza dough using these controls—all the way out to the edges of black and white, or with some room to spare.

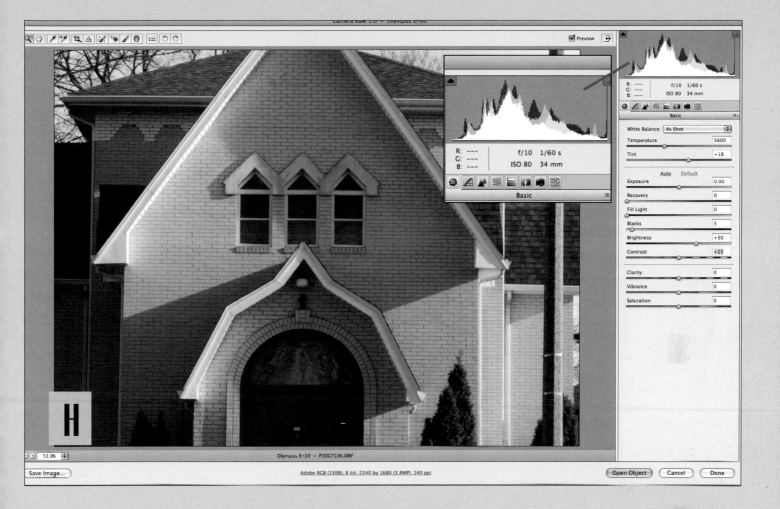

Contrast ★★★: Contrast, at the bottom of this
slider group, allows you to map the tones in
towards the middle—making them all middle-
dark to middle-light (low contrast)—or out to
the extremes of dark and light (high contrast).
Again, watch our histogram (image H). Normal.

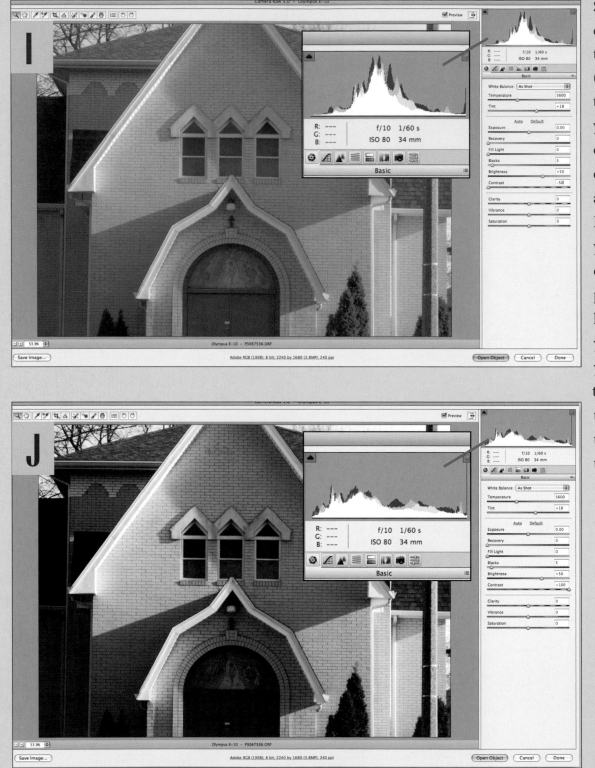

Sliding contrast down, tones move to the middle (**image I**). Now, to the high end, and you'll see a shift of tones out to the edges of the right and left (**image J**). Don't let it throw you that the high contrast setting produces a flatter histogram. Think of your pizza dough; if you want to spread the middle parts of the dough out to the edges, it's going to get flatter, right?

Recovery and Fill Light ★★:

Recovery and Fill Light are just some handy features that also work with the contrast curve. This is kind of like the air conditioning and cruise control in our rental car—they are there to make the ride a little more comfortable. Don't forget, however, that we are simply massaging the contrast curve. The Recovery slider pulls in detail from the highlights. The Fill Light slider, like Brightness, moves the midtones in the image up, but works only on the lower midtones. If you're shooting a model outside in direct sun, you add some fill light to soften the deep shadows the sun casts. Fill Light tries to do the same thing. It's just a handle that allows you to adjust a very specific part of the curve.

The Clarity, Vibrance, and Saturation sliders all deal with issues of saturation (chroma), or less scientifically, "colorfulness." Clarity deals with local contrast and Vibrance and Saturation adjust chroma. Suffice to say I don't put much stock in these controls, other than to sometimes tweak the Saturation setting a bit. Much more important is the Hue/Saturation tab and the Camera Calibration tab if you're looking to handle the saturation of colors in your image.

One last thing: Notice the Auto and Default buttons. Auto adjusts all the settings to preset limits (which, at this point in Adobe's software development, you cannot alter). My general feeling is that Auto doesn't work too well. The Default setting applies the Camera RAW default, based on the profile (or group of settings) that Adobe has developed for your camera. This actually does work pretty well, at least to get you into the ballpark. You can modify this in Settings by making your changes and saving it as the default (more about this on page 89).

Chroma: In a digital context, chroma contains hue and saturation data but not luminance (brightness) data. Chroma also refers to color.

Local Contrast: This effect increases visible detail and edge contrast in a specific area without increasing the overall image contrast.

The Tone Curve Tab

I have a little confession to make here. Before Camera RAW had a Curve tool, I complained incessantly about how it was lacking, and questioned how Camera RAW could be a professional product without a Curve tool, and on and on like that. Then Adobe added a Curve to Camera RAW. Confession time: I never use it.

One of the reasons I don't use it is because it is too deep into the camera "response" process. The curve function in a RAW processor reads the RAW file's values and maps them very specifically based on detailed information about the sensor and the camera. I've explained this to photographers when training them in high-end capture software like Leaf, PhaseOne, Sinar, and Hasselblad. Although you *can* adjust the curve, it's not something you probably *should* do. In terms of processing files for clients, the result can get pretty random when you mess with the curves.

With all of that being said, this tool is very refined and powerful. I'm going to pay my respects and move on (to quote my friend Paul, said while he was photographing some very significant yet somewhat ugly and hard to photograph sculpture), if for no other reason than I complained so enthusiastically about it's absence.

The first thing to understand here is that the Curve tab works with the information that the Basic tab is feeds it. You see the "source" histogram—that is, the histogram you've built in the first tab—and you also see the histogram in the background of the curve window. The curve can only modify what that Basic tab has prepared for it. To put it in slightly different terms, the Curve serves as the context for the Basic adjustments. You see the Basic adjustments mapped through the Curve's "rendering."

Using the Parametric control set, I can adjust the sliders and re-map the four basic areas of the curve—the Highlights, Lights, Darks, and Shadows. Here I've done a classic contrast boost curve (image A). I've moved the highlights up and made them brighter. I've moved the shadows down and made them darker. The effect is to make a higher contrast image.

Here's what I get when I click the "Point" tab (image B). I now have access to some presets in the pulldown menu (image C).

Now check out this little trick. In the point tab, the cursor turns into an eyedropper when I hit <Command>. The eyedropper will pick the tone it's on and send it right to the curve. Look at this example. The eyedropper is on the gray part of the image. There is a circle about half-way up the curve (image D). I click this and get a control point set right on the curve. Now I can make an adjustment based around that one specific point (image E). I can even use my arrows (up, down, left, or right), to precisely control that point, just as with Curves in Photoshop.

That's pretty much the extent of the Curves tab. If you need to make very specific adjustments to the files your camera is making and consider this a processing "profile," (that is, something you will use all the time in a very standard way), then set this up, save this setting in "Settings" (see page 89) and test it out.

Sharpening

Amount	25
Radius	1.0
Detail	25
Masking	0

Noise Reduction

Luminance	0
Color	25

Zoom preview to 100% or larger to see the effects of the controls in this panel.

The Detail Tab

The Detail tab allows you to control image sharpening and some limited noise reduction when the file is processed.

Here's the thing. First, this feature is different—subtly different, but different nonetheless—from Unsharp Mask. This is further confused by the fact that the controls are very similar. Second, there is what I consider pervasive misinformation about sharpening practices out there in the digital world, some of it originally evolving from scanning practices. In particular there's the idea that sharpening in the RAW process is akin to sharpening in the scanning process, which it isn't. (The presumption is that sharpening within the scanning process can potentially compromise image quality.)

The fact is that you must sharpen the file as it is processed or the file will be mush. This step is so crucial in the RAW file construction that many RAW processing systems either do not allow you to turn sharpening off entirely, or their settings at "no sharpening" are still applying some basic level of sharpening.

This makes a little more sense when you consider the whole RAW process and the scaling and demosaicing that must take place to create the image. You simply have to tone up the edges of the pixels by applying so-called "local contrast"—slightly exaggerating the differences between tonal values of neighboring pixels.

The process of going from a RAW file to a final print needs two steps of sharpening—one here in the RAW process, and one as a finishing step with Unsharp Mask. But it needs a balance: If you sharpen too much in RAW, you're going to have to take it easy in Unsharp Mask. But if you don't sharpen enough here, you won't have an edge to sharpen later when you print.

I most often use the default values for this set-ting. The only time I really mess around with these settings is when I'm making an extreme—and I mean extreme—enlargement and the degree of sharpening has to be spot-on.

The sharpening controls in the Detail tab work much the same as in Unsharp Mask, but un-like with Unsharp Mask, I rarely stray from the default. The noise reduction controls just don't work particularly well, but this is how I found them to respond. The Luminance slider blends areas that have similar brightness values, so ar-eas that are dramatically different—like edges—don't get blended. The Color slider simply sucks out primary R, G, and B colors wherever they appear. The result of both of these tools is, in my humble opinion, just to make a mess of the image and can only be truly effectively used in a "spot" strategy. If you have a nasty area, address the noise and mask it. I suggest you only use these adjustments on the areas of your image that really need it.

The HSL/Grayscale Tab

The HSL/Grayscale tab is a remarkable tool; it can be used to make precise adjustments to almost any color in an image, or to make global **camera profile** adjustments to Camera RAW for making a standardized correction to your camera files. (As you can see from the screen-shot, HSL stands for Hue, Saturation, and Luminance.)

Camera Profile: A camera profile can refer to two different things, both concerned with processing the RAW file to the most accurate color possible. Strictly speaking, it refers to a profile that is designed to take the camera's native color rendering and correct it to an industry standard—usually called an ICC profile. Some processors use "camera profile" in a looser sense, referring to a set of process-ing characteristics that apply to a specific camera model (or group of models).

A

Hue

I've opened a shot of the ColorChecker target because it gives me color patches that I know and love, and can see the effects of the adjustments I'm making (image A). I've clicked on the red patch with my Color Sampler eyedropper so I can see the individual color values (located in the upper left corner of the window). With the Hue tab selected I can go into every color on the chart and do whatever I need to do to correct or adjust the color.

I use this primarily in two ways. First, I can fix a camera's files that are consistently doing

Gamut Warning: Gamut warning points out parts of your image that are oversaturated or that might have trouble printing. These are colors that might not fall within the gamut range of your working color space.

Proof Setup: Simulates the look of a print within the specific parameters of an indicated device, such as a printer.

something I don't like. For example, my old Olympus likes to push the red tones to a saturated magenta hue, and that makes skin tones look just bad. The other thing I do is I can see if a particular color is out of gamut (using Gamut Warning and Proof Setup, and map it into gamut with the HSL/Grayscale tab.

Right now my RGB values on that red patch are 152, 13, 77. It looks too saturated and magenta to my eyes—and I trust what I see because my monitor is a good quality, **color accurate** display calibrated with a top **monitor calibration** system—so I slide the Red channel around a bit. I'm going to make two moves here. First, I take the Reds and slide them slightly from the middle to the orange side. Then I go to Magentas and bump them over towards red. This gives me a nice red rendering that I know matches the target pretty well (**image B**).

Color Accurate: A monitor that is capable of displaying full, accurate color.

Monitor Calibration: Adjusting a monitor with an industry-accepted calibration tool to achieve reproducing full, accurate color.

I can do this for every patch on the target, although I usually don't. I'll caution that you have to watch all the colors very carefully. There are some very subtle overlaps between hues, and if you use this for anything but a very fine adjustment it can quickly get ugly.

Saturation

Next I'd like to take the saturation down a bit, but again just for the reds. Click the Saturation tab; I've slid the Red channel down (image C). Now I'm pretty happy with the red rendering. Keep in mind that this is purely subjective on my part—it is how I prefer my reds to look.

I didn't refer to the target values of the ColorChecker, but just for laughs, let's look at what they are. Some ColorCheckers have charts showing the RGB values for each patch, but you can also find it pretty quickly on the web.

The little paper that comes with the chart says the RGB values for the red patch should be 203, 0, 0; I have 153, 33, 73 (image D). Does this concern me? Not really. My confidence is based on two things: a well-calibrated display and my personal preference.

Luminance

Finally, we have the Luminance tab. When you're thinking about luminance, just think "brightness." With this tab, I can select one color with surgical precision and make it brighter or darker without changing any other colors.

Want some help with HSL? Go to the Photoshop Preferences and click the "Color Picker" (Photoshop>Preferences>General) (image E).

Select "Apple." Now go to the Color Picker in your main workspace and you'll see this (image F). This is a tool to visualize HSL (image G). As you move the point away from the center you are increasing the Saturation of your color. As you move the vertical slider on the right, you're adjusting the Luminance. Here I've gone into the purples, increased the saturation about halfway, and dropped the luminance down a bit (image H). Working with virtually any color is possible using the HSL mode.

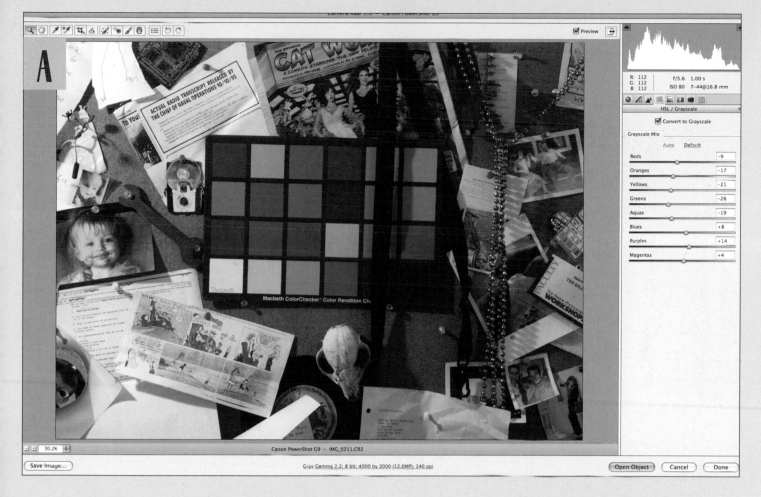

Let's move on. You'll see a little checkbox for "Convert to Grayscale." Click it. This gives you a grayscale conversion much like Channel Mixer in Photoshop. I can go into each color and control how bright it will be rendered when converted to gray. Here is the "Auto" setting (image A). (The Default setting goes to zeros, but again, you can set the default to whatever you want in the Settings; refer to page 89.) Let's quickly move the balance around and look at each patch in my ColorChecker, especially the reds and greens (image B) (see image B on the next page).

Pretty dramatic, huh?

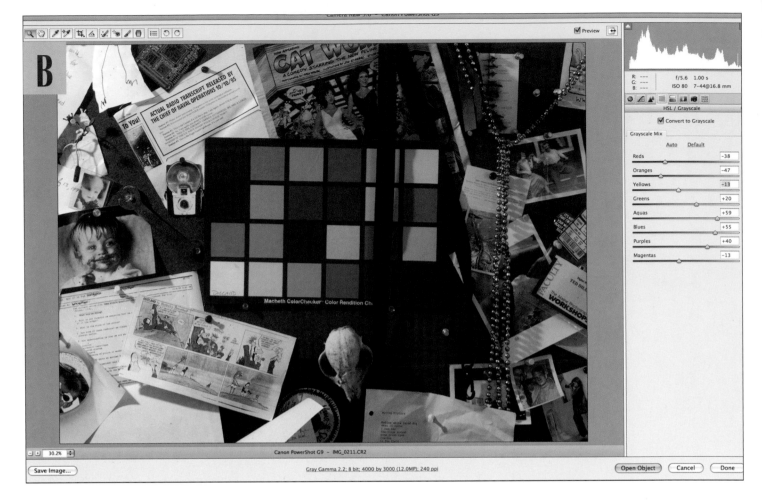

Note: With the Workflow Options information button, we're now shooting to a Gray Gamma 2.2 Color Space; that is, Camera RAW is going to take all our colors and, based on the decisions we make here, map them all to a grayscale space.

I use this for characterizing my camera in some cases, but most often I'll use it to spot-correct a color. If I have one color I don't like, I'll make a new Smart Object layer, go into the layer and make an HSL/Grayscale adjustment to fix the offending color, make a mask, and use my brush to select that part of the layer that affects the color I want to change.

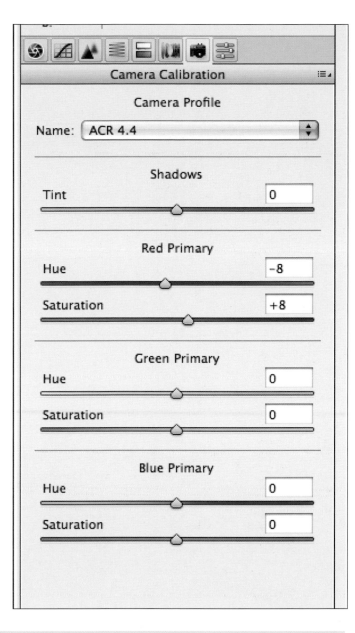

The Camera Calibration Tab

I'm going to skip to the HSL/Grayscale tab's cousin, the Camera Calibration tab. This simplifies the process down to the three primaries your sensor uses to make colors (RGB), and allows control to those channels through Hue and Saturation.

As you can see, this uses a "camera profile," which is a really sloppy use of the word profile. It is really a processing profile, and though it uses ICC profiles in handling the sensor data, it is not an ICC profile. It is a set of instructions characterizing the camera. Photoshop automatically picks it for your camera, and here, it has picked "ACR 4.4" (Adobe Camera RAW 4.4)." (I'm guessing this is because my camera was pretty new when I did this. Older cameras call up other profiles. My Olympus E10 brings up the Camera RAW 2.4 profile, for example.)

I don't use this much anymore because the HSL/Grayscale tab is so precise and fun to use; but this does have one thing I like, and that is the "Shadows" slider. This allows control, to some extent, over the amount of green-magenta shift in the shadows of an image. On a very rare occasion, I'll pump some magenta into a shadow to get that nice purple-blue glow at twilight.

ICC Profile: An ICC profile is a table of corrections that allows the color management system to apply corrections to a set of color targets. This allows the system to standardize many different devices from different manufacturers and correct them to perform at an acceptable industry standard. Every color device in a color-managed system has an associated ICC profile; however, some are called input profiles (scanners and cameras), some are display profiles (computer monitor), and some are output profiles (printers).

One of the more challenging aspects of writing books on digital photography is trying to keep up with the fast pace of changes and new products. You always know that as soon as the book ships off to the printer, someone will release something that is going to make a change necessary. Most of the time, I accept that, try to see into the future just a bit, and use my website, www.shootrawsmart.com, to keep readers updated. (Be sure to check out the Shoot RAW Smart Yahoo group at http://tech.groups.yahoo.com/group/shootrawsmart/.)

This time, though, just as we're going to press, Adobe released a pretty remarkable update to Camera RAW, Version 5.2, and I owe it to you to run through a few of the features, however briefly. There is one feature in particular—the "Snapshots" tab—that influence your Smart Object processing. There are a few others that are nice and I want to go through them, if for no other reason than I'm worried you're going to be confused by screenshots shown in the book not matching what you're seeing on your screen. Adobe does this sometimes. They will often release an update that just adds support for the latest camera models, and sometimes slip a major improvement under the door. This is such a case; v5.2 not only looks like a nice addition, but it seems to be an indicator of what's coming down the road.

The Snapshot Tab

The Snapshot Tab is the feature that has the most relevance to the Smart Object RAW processing. It's found at the far right of the tabs (*image A*). Snapshots save all our settings in the current state when you select this little icon at the bottom of the tab (*image B*). Here I've done three versions: a normal

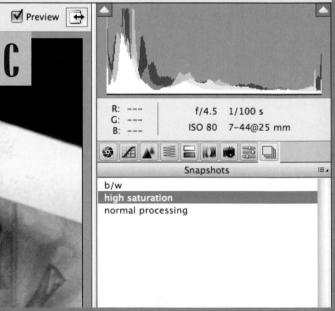

process, a grayscale version, and a high saturation version (*image C*). Snapshots are saved when you process the file, and in the Smart Object workflow you can save multiple treatments of an image all in one Object.

This is great if you're using a file for a few different purposes, if you can't make up your mind which way you want to go on a file, or if you just want to backtrack in a "History"-like way. Save your trail of breadcrumbs and you can always go back home or to any stop along the way. The trail is not linear either; you can switch back and forth between versions at your leisure.

Keep a few things in mind. These snapshots don't move from file to file; that is, there's no way to save image adjustments on one file and move it to another file (except by saving the treatment as a Setting; see page 89 for a discussion of this). Also, saved Snapshots are duplicated when you make the "New Smart Object via Copy" move, so if you put them in first, you can use them later (see page 126 for more on that).

Other New Features

There are some other niceties Adobe's added that are cool, but not as earth shattering in our workflow. The Targeted Adjustment Tool (*image D*) is a sweet control—it allows you to simply click an area and drag up or down to make an adjustment. The default adjustment affects your Curve (see page 70) but you also get the option to work on the Hue, Saturation, Luminance, and Grayscale mix (*image E*). The Grayscale Mix is one feature we talk a lot about in the Black and White Pipeline book; you can pick a tonal value and adjust it as a function of your basic channels. I've grabbed one spot on my image and moved it up for this example (*image F*). The tool goes right to the channel needed without my knowing what color I'm working on—in this case the green—and gives it the right boost.

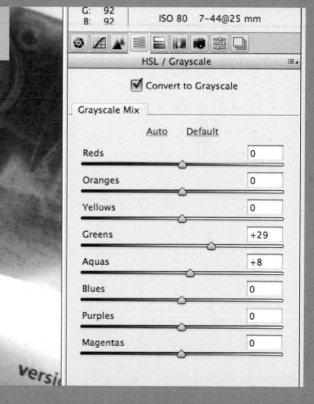

If you're doing Black and White with Smart Objects and want to layer a few different conversions on there, this lets you effortlessly make different grayscale renderings without having to figure out exactly what channel needs to be adjusted to get the effect you want.

Another nice feature is the addition of "Camera Profiles" in the Camera Calibration tab (image G), where you can select a variety of renderings from a big list. Not only that, but Adobe has a DNG Profile Editor that allows you to build your own "recipe" and import it into Camera RAW. (http://labs.adobe. com/wiki/index.php/DNG_Profiles:Editor) You must start with a DNG file to use it (see page 258), but you can apply it to any file once it is there. This even has what looks like an ICC profiling chart as part of the package, and gives you some very high-level controls over how you're mapping colors (image H & I). (The DNG Profile Editor is still in beta at the time of this printing.)

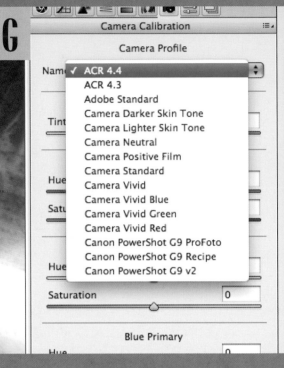

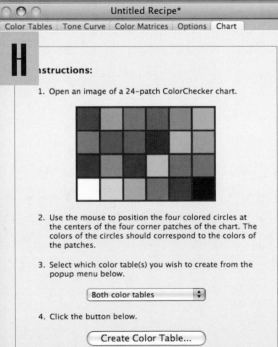

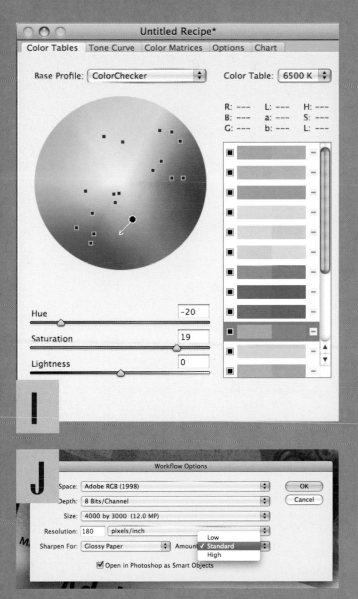

Finally—and something to actually avoid in the Smart Object process—we have the addition of Output Sharpening in the Workflow Options (*image J*). This is intended to expedite processing when you're trying to get files to a print-ready state and you've done the correct in-camera "pre-processing" sharpening. In any process such as ours, where you are going to play with sizing and apply additional sharpening, this feature can make a mess really quickly. I'd suggest avoiding it for now, but I will be watching this to see if it goes from being a fairly rudimentary perk to being as powerful as, say, Unsharp Mask.

The Split Toning and Lens Correction Tabs

I know I'm going to suffer the slings and arrows for this one, but nevertheless: I think these tabs are silly. I'm sure that, for Adobe, including these tabs is a very wise decision—like the inclusion of the "Red Eye" tool—but I'd be happier if they pulled these tabs out and made my workspace cleaner. That isn't going to happen, so here is a mention, and a mention of both tabs at once, for that matter, but no more.

Here they are. The Split Toning tab lets you deal with color casts only in the highlights or shadows. The Lens Correction tab lets you fix poor lens performance—which can show up as **color fringing** and **vignetting**—or, it lets you introduce various effects, like the **"Holga"** effect.

Like I said, tricks are for kids.

Color Fringing: Color fringing is caused by lateral chromatic aberration, one of the two types of chromatic aberration in lenses, both of which arise from dispersion in glass, which is the variation in the lens' ability to bend light (its index of refraction) with wavelength (color). This appears as magenta and green bands at contrast boundaries. Color fringing increases with the distance from the center of the image.

Vignetting: Vignetting indicates an unintended darkening of the image corners in a photographic image. There are three different mechanisms that may be responsible. Natural and optical vignetting are inherent to each lens design, while mechanical vignetting is due to the use of improper attachments to the lens.

The Presets Tab (and Settings)

We go from the silly tabs right back to one of the most powerful features—the Presets tab, which is linked to the Settings button. The Settings button is an extremely small button that looks like three lines, and is located in the upper right corner of all the tabs.

Take a look at that menu. The first five let you apply various existing settings to the active image. The Image Settings are the settings that are read from the existing XMP data attached to the image and brought into Camera RAW. Camera Raw Defaults applies either the factory defaults Adobe has designated for your camera—based on that "camera profile" we discussed earlier—or a default that you have created. Previous Conversion applies the same settings from your last file to the new file. The Custom Settings simply lets you know that you've made changes and haven't saved or named them as a preset. Finally, Preset Settings are settings groups you've saved in order to use again. Here you can see a preset for my Olympus E10 in the Presets list.

Look down to Load and Save Settings; this is the same as all the "Load" and "Save dialogs in Photoshop" controls. Load allows you to get settings from wherever you've saved the settings files—even from a server or jump drive. Save means you can save any settings you've made as a preset.

Holga: The Holga is a plastic lens "toy" camera designed for use with the 120 film format. Along with a large group of similar cameras, it has been widely adopted by the fine-art photography community for the characteristically deconstructed effects it produces—innocent, raw, impressionistic look created with lens blur, light leaks, and lens vignetting. It is an attempt to go back to the roots of the photographic process, a non-technical intuitive way of working, and for many is the antithesis of digital photography.

This is where you can make your own processing "profile" for a camera. Make your settings based on either a detailed look at what your camera does consistently or your experience with processing the camera's files. For example, my E10 puts too much magenta into the reds. I know that because I've processed the files for years and had to take magenta out of every one. Or, I know that because I've looked at the ColorChecker under various light sources and the camera always does that same thing to red. Save the settings, apply the Preset, and you've tailored Camera RAW to your specific tastes, for your specific camera.

If this is your only camera, or you want these presets applied to every file (including the previews in Bridge), then set this as your default. Select "Save New Camera RAW Defaults." Now these settings will be the first choice applied by Camera RAW. If you want to go back to the factory setting, just select "Reset Camera RAW Defaults."

This is a great time saver and a pleasant way to work. Everyone has a way they like to work, including some favorite "moves," and this simple menu lets you do a little back-end work to save yourself from having to do the same thing over and over. If a process or "move" keeps showing up in your normal working process, stop and ask yourself if this is something you use a lot. If so, then save it as a preset; be sure to set aside some time and actually list out things you'd like to load here. Have a beer, turn the phone off, and do some prep work. You'll thank yourself later when the crush hits.

Conclusion

That pretty much covers Adobe Camera RAW. For all the bells and whistles, always think back to Color, Contrast, and Scaling, and not only will you simplify your processing and understanding of Camera RAW, but you'll be able to sit down in front of any package—from Aperture to Lightroom to Iridient Digital's RAW Processor—and jump right in to working with almost 90% of the features and controls.

*B*ridge has evolved—or rather, Adobe engineers have developed it—into a remarkably useful tool. It started as a browser in Photoshop as the aptly named File Browser (Photoshop 7, if you're keeping score); Adobe then moved it out of Photoshop and made it compatible with the entire Creative Suite, thus "Bridge."

All RAW file editing programs have a browser feature—a way to preview, navigate, and access any number of files at once—and that's the way File Browser started out, except this was not only for RAW images, but for any Photoshop-compatible image at all. Basic browsers usually provide a way to sort images, rank them, maybe even add tags, and get close-up views of them so you can make better sorting decisions. The only problem is sorting through all the available and useful features. Ultimately any browser must be a clear, fast, and efficient tool.

Lightroom and Aperture are also built around the framework of a browser, but with one key feature: a RAW processor. They are specifically designed to be a one-stop shop for your file sorting, processing, and storing. They are great devices, and you can use them to file and sort for Smart Object files. Because they can't edit Smart Objects, even though Lightroom 2 can create Smart Objects, I'm not going to talk about either of them here; instead I'll give you a quick overview of Bridge, because it is an essential part of the process. (For the record, don't think you'll see

Apple integrate Smart Objects in Aperture, unless the process becomes more of an industry-wide standard.)

Here's the briefest of introductions to Bridge. First take a look at the default workspace (*image A*), showing all your files in a folder. In the upper left, you have your "Favorites" tab selected. My first act is to select "Folders" to get to a nice directory (*image B*). Now I can see right where I am.

In the upper right corner are your Workspace presets (*image C*).

Click the Filmstrip for the filmstrip view (image D). The Essentials tab gives you an overview of the thumbnails and the Metadata tab gives you the view of all the metadata information (image E). The Output view is a new addition to CS4, and gives you all sorts of packaged printing and web publishing options. My personal favorite by far is the filmstrip, but that's just me.

You can grab the edges of the windows and adjust them to resize the whole thing. If you do that, and like what you've done, you can save that workspace as a preset in Window>Workspace>New Workspace *(image F)* and name it *(image G)*. (Note all the available presets.)

On the left border of the Filmstrip view, I have tagged images and rated them with the star rating system (*image H*). I rate my favorites with five stars (*****) by clicking the little dots shown here (*image I*), or I hit <*Command+5*> on my keyboard, or whatever number corresponds to the star rating I prefer. I can select just the files with a specific rating by clicking next to the Rating item (*image J*).

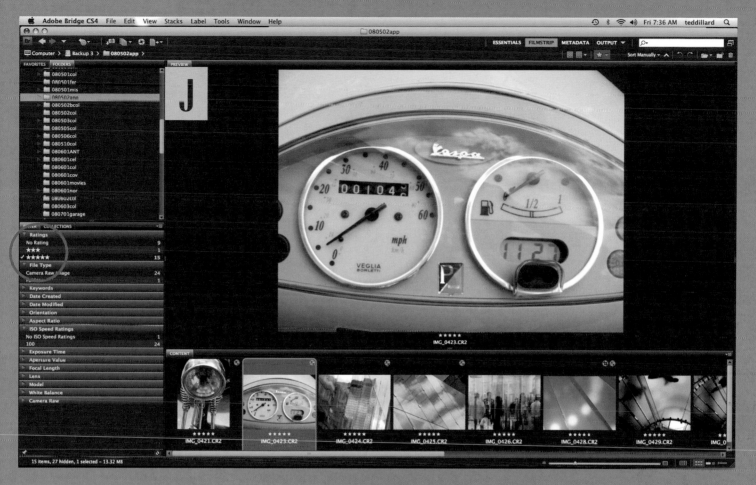

I can use Bridge in Creative Suite to synchronize the Color Settings in all the programs in the Suite by going to Edit>Creative Suite Color Settings (*image K*). Bingo.

Suite Color Settings

Synchronized
Your Creative Suite applications are synchronized using the same color settings for consistent color management.

Monitor Color
Preparation of content for video and on-screen presentation. Emulates color behavior of most video applications. This setting is not recommended for documents with CMYK data.

North America General Purpose 2
General-purpose color settings for screen and print in North America. Profile warnings are disabled.

North America Prepress 2
Preparation of content for common printing conditions in North America. CMYK values are preserved. Profile warnings are enabled.

North America Web/Internet
Preparation of content for non-print usage like the World Wide Web (WWW) in North America. RGB content is converted to sRGB.

Ted's setting
Preparation of content for common printing conditions in North America. CMYK values are preserved. Profile warnings are enabled.

☐ Show Expanded List of Color Settings Files

[Show Saved Color Settings Files] (Apply) (Cancel)

This allows access to all the standard and custom presets (*image L*). And of course, you have the ability to "Place" RAW files into images in Photoshop as Smart Objects (see page 161): File>Place>In Photoshop (*image M*).

N

O

P

The last thing you really need to know to get you going is the Loupe tool. In the Filmstrip view, the main image is the "Preview". Your cursor, when over that preview, shows up as a "+" magnifier. Click, and you get this (*image N*). *<Command + >* or *<Command – >* zooms the magnifier in or out.

To move it, click elsewhere or grab the Hand tool and slide it around. To make it go away, click on the spot it's looking at—the small pointy part (*image O*)—or click the "x" on the other corner (*image P*).

Now you have enough information to make you dangerous. I encourage you to get in the habit of using Bridge rather than using your Finder (even with its slick new viewing options in Leopard), simply because it's more powerful and keeps you within the workflow. As you use it, you'll learn more about it. As it is more fully developed, it will only become more integrated and more powerful, and you'll be developing your habits on a good foundation.

CHAPTER 3:

PHOTOSHOP LAYERS AND MASKING

Understanding Layers

Smart Objects and Layers are intrinsically linked. The Smart Object exists solely as a Layer, and you must understand Layers—or at least some of the features of Layers—to start working with Smart Objects. I only use some of the very basic features of Layers and Masking, and if you really want to go down this rabbit hole there are some great resources out there. Probably the most definitive book is Katrin Eismann's *Photoshop Masking & Compositing*. I certainly wouldn't presume to be an authority, but I can show you all about the basic tools in Layers and Masks that I know and love.

It is best to understand the basic idea of Layers first. Probably the most useful analogy for Layers is the idea of an overhead projector; place a transparency on the projector's glass and it is displayed on the screen. Put two transparencies together and you see them both. I like to go even simpler. Just think of a light table. Place a transparency on the surface and it is a Layer. Place a few transparencies on the light table, and I can see them all stacked on each other. I can move them around, mask them out (to make parts of them invisible), and I can determine what is on top and what is on the bottom.

Let's go into Photoshop, and with some really basic images, try to get a grip on Layers.

I've just made a simple image with three areas of red, green, and blue. Here are the layers, one at a time (image A) (image B). I activate them by just clicking on the small eye icon; when the eye icon is there, that layer is visible; when the eye icon is clicked and disappears, the layer is there but invisible. Just like I was stacking these on a light table, I am seeing the top image, the green box, over the top of the other images (image C). The blue sits behind everything, on the bottom.

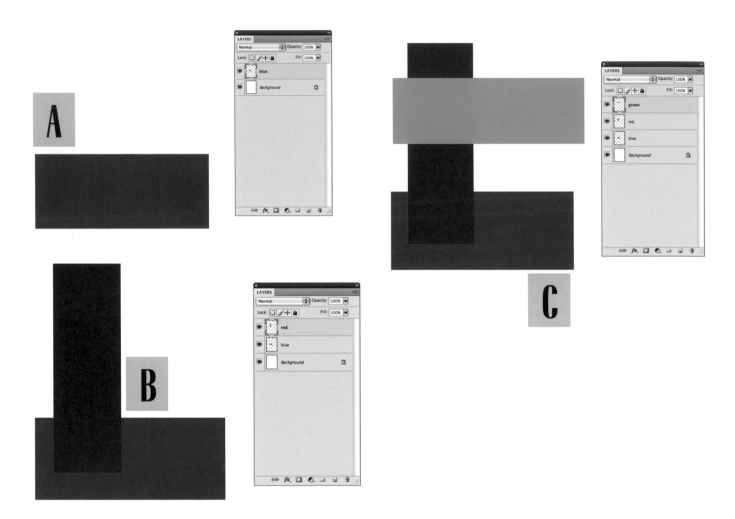

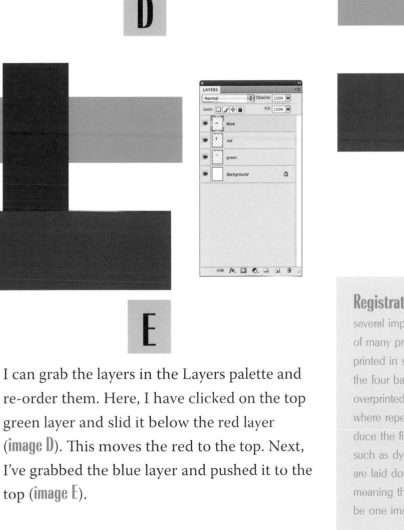

I'm just messing with how these layers are ordered—I'm not changing their position, or their "**registration**." I can do that with the Move tool. I've grabbed the red patch and slid it to the right (**image F**).

I can grab the layers in the Layers palette and re-order them. Here, I have clicked on the top green layer and slid it below the red layer (**image D**). This moves the red to the top. Next, I've grabbed the blue layer and pushed it to the top (**image E**).

Registration: A graphic arts term referring to aligning several imprints or component layers of a print. In the case of many printmaking techniques, several different colors are printed in separate "passes," such as offset printing, where the four basic colors of cyan, magenta, yellow, and black are overprinted to produce a full spectrum of colors; silkscreen, where repeated printing of separate solid areas of colors produce the final design; or photographic darkroom techniques such as dye transfer, where the continuous layers of color are laid down separately. The separate colors must register, meaning they must line up perfectly so that they appear to be one image.

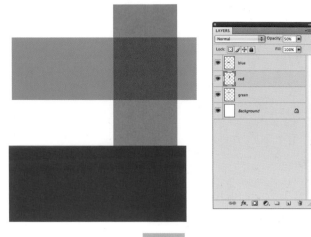

Understanding Masks

Actually, I think Masks are one of the simpler ideas to get a grasp on in this process, but there are a few steps you have to go through to get there, and that's where people get lost. For now, this is just an illustration of how Masks work, not a how-to on Masks. Get the concept, and we'll dig into how to use them a little later.

G

We're working with solid blocks of color here, but what if we want our layers to be a bit transparent, to show through other layers? This can be accomplished with the Opacity control, found in the upper right corner of the Layers palette. To show this, I've taken the red layer and made it transparent by sliding the layer's Opacity down to 50% (**image G**).

It is as simple as that. All Layers work like this, whether they are Image Layers (as in the example), **Adjustment Layers**, or our fabulous Smart Objects. Now, let's look at the feature that makes Layers so powerful: The mask.

A

I've set up a big black dot on the background, and plopped a blue dot on top of it. I want to mask part of the blue dot, so I can see the black dot (**image A**). Think of this like a magic eraser on my light table—it allows me to mask (or erase) specific parts of layer of it so the stuff underneath it can be seen.

Adjustment Layers: An adjustment layer typically applies a common effect, like brightness or saturation, to other layers. As the effect is stored in a separate layer, it is easy to try it out and switch between different alternatives, without destroying the original layer. An adjustment layer can easily be edited, just like a layer mask, so an effect can be applied to just part of the image.

At the very bottom of the Layers Palette is the "Add Mask" button (image B). I push that and I get a white rectangle next to my layer's icon (image C). Now, I mask the layer. (I discuss this process in detail on pages 111-113.) Here's the key: Black, on this rectangle, is the part of the mask that is opaque. This means that part of the mask is covering up the image and not letting any of it show through. White is transparent, letting the image shine through completely. See that little black spot on my mask (image D)? That is going to cover up my blue dot in that specific place (image E).

How cool is that? I can make layers and move them around—I can put one on top, move another to the bottom. I can even select—very precisely—what areas of the layer are visible.

ruby: Ruby refers to "rubylith," a red graphic arts film that is used to make masks and stencils photographically. Lith, or Ortho, film is not sensitive to red light, thus a red stencil can be used to block light (orthochromatic—sensitive to only blue and green light; panchromatic—sensitive to a complete spectrum). This is useful in many printmaking and graphic arts applications when manually cutting shapes (traps), and transferring images and stencils to a photographic film or light-sensitive emulsion. Rubylith is also used for making silkscreens, since the gel surface can be softened with lacquer thinner and adhered to the silk, creating a stencil.

The key thing to understand about a Mask is that it is a Selection tool. It allows you to select the parts of that Layer you are going to use. Whether your layer is an image layer or another type of layer, the Mask lets you choose what part of that layer is seen or applied. It is a remarkably elegant and simple device, but like many elegant solutions, there's a lot going on behind the scenes that gives it such a simple appearance.

There you have it. The ability to add information in a Layer, and then decide exactly how much to that information you're going to use, is the cornerstone of the Layer/Mask process.

Here's an enlarged shot showing just the Mask itself (image F), and here is a shot showing the Mask, (in red, or "ruby") superimposed right on the actual image (image G).

Example: Masking a Photograph

This is great in theory, but how does it have any bearing on real photographs, not just blocks of color? Here's a quick demonstration of masking photographic images.

I start with a shot of the Zakim Bridge (image A). Now, I have a shot of my wife, Teresa (image B). I'm going to merge the images. (I know it's a cheesy idea, ok? I just happened to have these shots together.) The first step is to bring one image in as a layer on the other image, and you do that just with the Move tool. Click, drag, plop, and you have a new layer (image C).

Now I need to "register" the image of Teresa—that is, I have to line it up to where I want it. I've turned the Opacity down temporarily so I can see through it to place it where I want it to fall on the bridge shot (image D). I use the Move tool to slide it around and put it where I want it (image E).

Now, I get ready to mask out the areas I want to eliminate, those being the brown background in Teresa's shot. I make a mask (image F).

Using my Brush I paint black on my mask to hide the brown background (image G). This shows you the image and the mask (image H). The white areas of the mask let Teresa's head and face show; the black areas of the mask cover up the background.

Remember one simple thing: The Layer Mask controls what parts of that Layer are used. In this case, the mask controls what part of Teresa's photo is used. The Layer Mask is a selection tool.

Basic Adjustment Layer Masking Steps

Layers Palette: Visible. (Window>Layers checked)

Step 1. Preparing the Tools

Brush Tool: Select the Brush Tool, and use these Brush Settings as a starting point:

Mode—Normal

Opacity—50%

Flow—50%

Color Picker: Go to the Color Picker icon, and by clicking the small black/white squares, set the Foreground/Background color to white/black. The Default colors are a black foreground and white background. (The two-headed arrow switches the background and foreground colors.) (Keyboard shortcut: Hitting <d> will set the squares to the default black and white colors.)

Step 2. Creating the Layer and Mask

Click the black/white circle at the bottom of the Layers Palette and select "Create new fill or adjustment layer." In this example, I select the Levels adjustment and make the image darker.

Select the adjustment layer's mask. This is the white rectangle next to the Adjustment icon, in this case, the "Levels." The mask is made automatically when you create an adjustment layer. Now, turn your mask black with the keyboard shortcut <Command+i>.

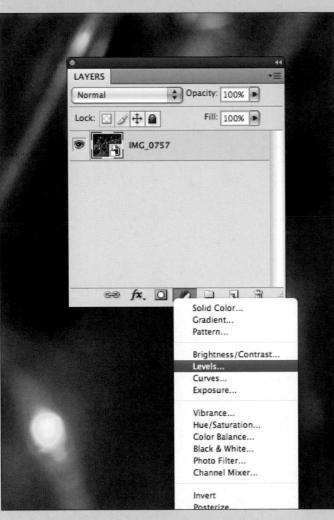

Step 3. Making the Mask Selection

With the now black mask selected, use the Brush tool to "paint" white on the black mask on areas that you want to activate or be visible. This shows a small area of our adjustment that will "show through." If the adjustment makes the image darker, this is the only area that will be darker.

Keyboard shortcuts: <{> and <}> makes your Brush a smaller and larger diameter. <X> switches the foreground/background colors.

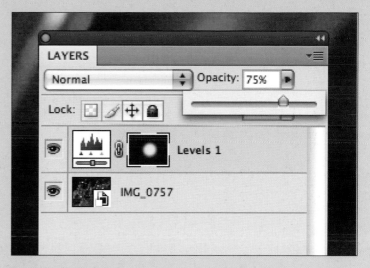

Hint: The Opacity button on the Layers palette (different from the Opacity setting for the Brush Tool) allows you to alter the overall effect of the adjustment layer.

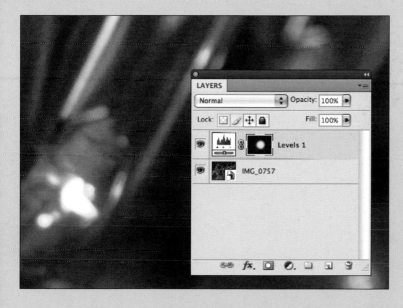

Hint: Painting black over a white area of the mask covers the edit, allowing you to change your selection.

Making the Mask with a Selection

One important aspect of masking a layer is controlling which areas of the mask are going to be black or white, opaque or transparent, somewhere in between, or gray. There are a few different ways to do this, but one route apart from the Brush tool is to make a selection using any of the Selection tools, then create the mask by selecting the mask button at the bottom of the Layers palette.

Here is a simple illustration: I'll use the shot of Teresa again (image A). I've dropped in a white background layer for the sake of clarity. I use my Rectangular Marquee tool and select a rectangle right in the middle of the photo (image B). I click the "Add Layer Mask" button and I get a mask based on my selection (image C). Photoshop assumes I want to keep the piece of the image I've selected, so by default it builds a mask that blocks off everything not selected.

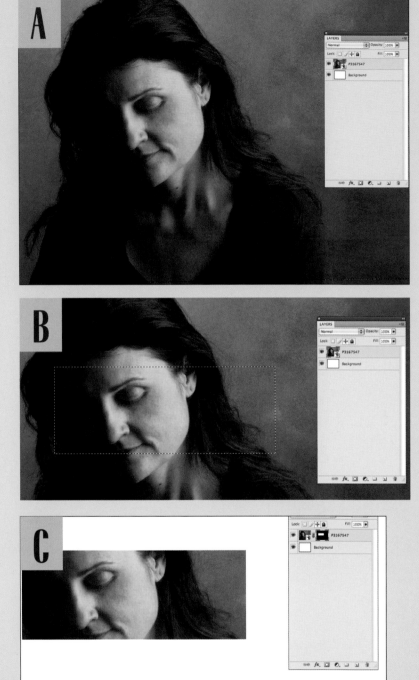

On to a more practical example: I've used the Magic Wand tool to select the background (image A). (Yeah, yeah—I know the Magic Wand is a cheap trick; hold on and see where I'm going.) Once I have the section selected I hit the Mask button and there is the silhouette. Well, the reverse silhouette—it has blocked Teresa out, not the background (image B). No worries: Select <Command+i> and it "inverts" the mask to give me the selection I want (image C).

Any Selection tool allows you to invert your selection, so you can build masks based on any criteria you like (even things like Selective Color). But there's another precise method that allows you to manually control, pixel-by-pixel, what is masked and what is kept. That is the method of actually drawing or painting right on the mask itself. Here's how that works.

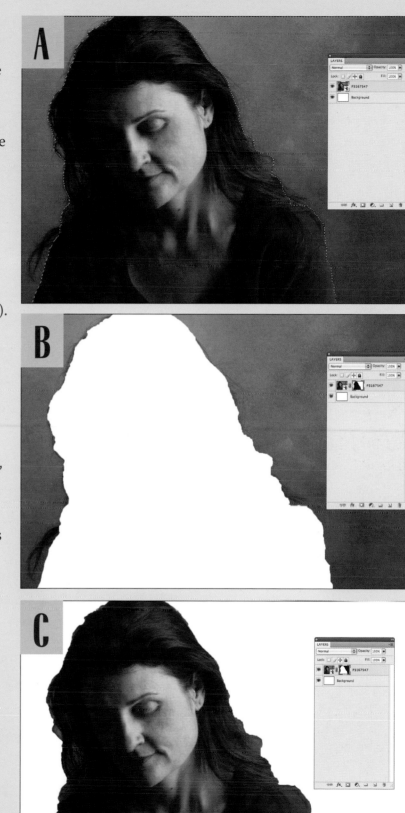

Essentially what we're doing is taking a very soft brush, "turned down" quite a bit, and then painting black or white on the mask. Let's go back to the image I've masked and refine it a bit (image D).

I've set up the Brush tool to paint white, at 50% flow and 50% opacity—I'm painting directly onto the mask (image E). This opens the areas of hair and shoulder that were haphazardly selected by the Magic Wand when we used it to make the mask. As I refine the mask, I make the brush increasingly smaller for more precision. I can then go in and—switching the Brush to paint black—cover the areas I've overshot to tighten the mask (image F).

This can be as precise a selection as I need simply by giving the Brush tool a harder edge and making it smaller. Here I've cut it down close to it's minimum size, made the edge as hard as it gets, and literally cut pixel by pixel around each hair (image G).

The truth is, I use this mask editing method almost exclusively. Most often, as you'll see throughout the book, I use the various layers to burn, dodge, and apply spot corrections and filters. The Brush method of applying a mask feels very much like working in the darkroom and is a very natural and intuitive way to work on an image; the big difference is now I can go back and change it later.

This process is a lot like riding a bike. Learning it may seem difficult at first, but once you get through the process and repeat it a few times, it becomes a rhythm of working that quickly turns into a reflex. It's a strong fundamental foundation on which you can build a whole range of techniques; whether you're starting out with Photoshop or you're a seasoned pro, it will quickly become the anchor of a fast, efficient workflow.

Don't worry if you feel like you are missing something here. We are going to hit this from many angles.

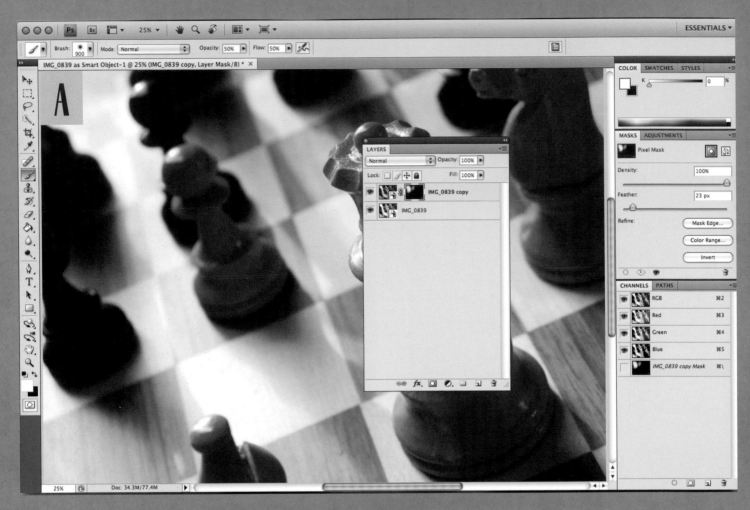

One small feature in CS4 kicks masks to the next level, and that is the Mask Panel. This gives you easy access to some powerful controls for your masks (*image A*). Once you make a mask, you can select the Mask tab and access these controls: Density, Feather, Refine Mask Edge, Refine Color Range, and Invert (*image B*).

IMG_0839 as Smart Object~1 @ 25% (IMG_0839 copy, Layer Mask/8) * ×

Refine Mask

Radius: 1.0 px

Contrast: 0 %

Smooth: 3

Feather: 1.0 px

Contract/Expand: 0 %

OK
Cancel
Default

☑ Preview

Description

Press P to toggle the preview of the edge refinements. Press F to cycle through the preview modes, and X to temporarily view the image.

C

IMG_0839 as Smart Object~1 @ 25% (IMG_0839 copy, Layer Mask/8) * ×

Refine Mask

Radius: 1.0 px

Contrast: 0 %

Smooth: 3

Feather: 1.0 px

Contract/Expand: +37 %

OK
Cancel
Default

☑ Preview

Description

Press P to toggle the preview of the edge refinements. Press F to cycle through the preview modes, and X to temporarily view the image.

D

Here I've selected Refine (image C), and directed it to Expand the mask (image D).

You can dive pretty deep into this and it's a great panel for some fast fixes to your masks for issues you'd have to handle the "long way" before CS4. For anyone doing in-depth compositing and masking, it's an excellent addition to the arsenal. For us, making some simple masks of RAW layers, it's a nice control panel we might use occasionally, and certainly one I'm going to keep up on my workspace.

CHAPTER 4:

THE SMART OBJECT

What is the Smart Object?

What exactly is a Smart Object, and where does this strange name come from?

An "object," when the word is used like this, is programming jargon. Any **application** uses a string of commands, or instructions, that are essentially "if-then" directions. These directions can refer to objects within the string of information. Say we have a value for the luminance of a pixel. We can say, "If the value is less than 150, then translate it into dark gray," or something similar. The pixel value in this case is our "object."

A Smart Object is more of a package that has it's own tasks—a set of commands within the commands. In Photoshop, a TIFF file has a set of **bitmap** instructions: "Go here, make a pixel with the value 12, 120, 43." When you add a Smart Object layer, you get a new "package" of instructions. "Go here, find this image, and open it."

Application: A more precise term for a computer program, or what is generally know as software. Photoshop is an application.

Bitmap: A method of storing information that maps an image pixel bit by bit.

Here's the analogy. Your Mom says, "Go to the second shelf in the pantry, grab a teabag, and bring it to me." That is her version of an **algorithm**, and the teabag is the "object." Now, suppose she says, "Go to the kitchen, get my teabag, put it into a teacup, add water, and put that into the microwave." Now, she's asking you to use an "object" that has it's own set of instructions—that is, the microwave. When you push the "Start" button, you're setting into motion a number of additional instructions beyond the simple request by your Mom.

Algorithm: An algorithm is a sequence of commands, used by programmers to specify, in an if/then format, how an application will process data. It uses a basic yes/no, if/then logic structure. For example, an algorithm would ask a question, requiring a yes or no answer: is the value less than 100? If "yes," go to line 140, if "no," go to line 144. Applications like Photoshop are built on complex series of these basic strings of commands.

XMP metadata: Metadata is a term for the descriptive information embedded in and image or other type of file; the two most common types are XMP and IPTC. XMP (Extensible Metadata Platform) was created by Adobe in 2001, and facilitates embedding and storing metadata into a file from a variety of applications, and supports IPTC metadata (IPTC is the original metadata standard developed in the 1990s to apply attributes and information to various file types).

What is interesting—in a totally nerdy way—is that programmers use a kind of "location" to place these objects and then refer to them using a number, called an instance identifier (or iid). Using Photoshop to peek at the **XMP metadata**, we can actually see the addition of these "addresses."

Open a RAW file (**image A**), go to File>File Info,

and we see this screen (image B). Since this is an unsaved Photoshop image, I've got nothing added. However, as soon as I save it, I see the addition of a line in the metadata: XMP Media Management Properties. I go to File>File Info of my TIFF, and this is what I see: image C.

Now, I open the xmpMM:History folder and see a couple of things—most importantly the [1] (struct) and [2] (struct) lines (image D). Here's where it gets interesting. (Well, here's where it gets nerdy.) If I make a new Smart object layer and save it, I get another (struct) line (image E). Those lines have a section that includes "xmp iid"; this is the "instance identifier," or the line that tells you the unique location of this information for that one layer. This is like if your Mom was totally nerdy, and she renamed everything with a number. Her instructions say, "Go to 452 and push Start." You then go through the entire house, checking numbers on everything, until you get to the microwave, which has been labeled "452." This is exactly what the computer does. It tries every possible option, asking a yes/no question. "Is this 452? No? Is this 452? No. Is this 452?" and so on until it finds the "yes." This is exactly how digital processing works. We have two possibilities, "on" and "off," or "0" and "1." The computer can slam

through all the possible variations a lot faster than we can (going room to room, checking the numbers on every single item). As programming has grown more sophisticated, it has become more efficient. Now the command would be, "go to object K" (Kitchen) and look for "452."

There is actually a reason this logic helps us understand Smart Objects. Later on, we're going to explore how copying the Smart Object layer works and some of the pitfalls and obstacles we must be aware of, and it's all because of this "container" at this "address." Each one is complete, and each one is distinct and separate.

We'll see about that a little later!

The Smart Object Menu

A good way to familiarize yourself with Smart Objects is to look at the menu under Layers. Layers>Smart Objects brings you to a nice little list of things you can do.

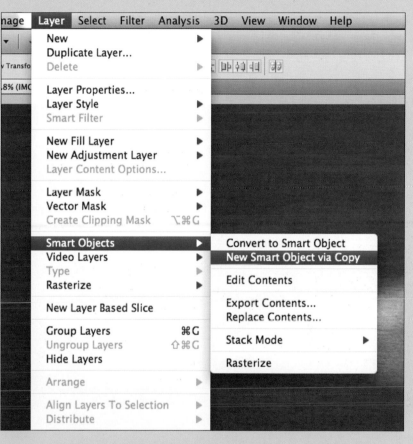

Convert to Smart Object: The first selection, "Convert to Smart Object," allows you to take a layer that is not "Smart" and make it Smart so you can apply filters and make them "Smart Filters." Smart Filters, as we will see, allow you to go in and re-adjust them. You don't just hit a filter and that's the end of it; by double-clicking the filter icon you can get back to the original filter settings. But it has to be on a Smart

Object. If you're working on a layer that is a normal image layer and not Smart, and you convert it to a Smart Object, this does not mean that you can get back to the RAW file that the image came from. That's gone, if it ever existed. It just means you've altered that Layer to accept Smart Filters.

New Smart Object via Copy:
The next selection we use frequently—so much so that I've built a keyboard shortcut to it. (Building Keyboard Shortcuts can be found on page 235). "New Smart Object via Copy" makes a new, unique Smart Object, but reads from all the edits you've made to the Smart Object's source (that source usually being the RAW file). If you've made adjustments, added filters, or masks, it will make a new layer with all that included. It does not make a new Smart Object from scratch. This is good to know; it becomes very important to know exactly what you are making and what's been done to it, even before you start working on that one layer.

You must keep this separate from the idea of copying the layer as you would any other layer. If you do that, the Smart Objects are linked, they refer back to the same "object." What you do to one is going to affect the other. The "copy" function does not really copy the object; it copies the attached instructions, and thus each change to those instructions.

Edit Contents:
"Edit Contents" in the Smart Object menu brings you back to the Camera RAW adjustment window, and can be done by double-clicking the Smart Object icon in the Layers palette.

Export Contents:
The "Export Contents" item is neat in my opinion. It lets you rip the actual RAW file out of the layer. It doesn't make the layer go away, it just takes the layer, converts it to the original RAW file, and lets you save it. (See the "Archiving" discussion on page 252.) This is nice if this layered file is your "archive"—your source image—and you want to get to the original RAW file to work on it in another RAW editing program, for example.

Replace Contents:
"Replace Contents" lets you drop in a different file and use that instead of the one you had. This is handy when you are working with various images composited in the layers, as with the HDR process described on page 242. You're working with your image, you can't get enough out of the highlights, and you think, "Hey, let's grab that 2-stop EV compensated file for those highlights and just drop that in for my "burn" layer." (Don't worry, we'll go into this.)

Rasterize:
Finally, "Rasterize" slams your Smart Object down to a normal image. You lose all the "Smart" capabilities, but sometimes you need to run this so you can use tools that aren't compatible with a Smart Object.

Armed with this outline, we'll look at some details in processing with Smart Objects in the second part of this book.

XMP stands for Extensible Metadata Platform. Extensible essentially means expandable or extendible. XMP is a platform, a structure for writing programming code, intended to be added to, extended, to accommodate whatever the future will bring.

You're going to see XMP referenced in two places. First, when you make an adjustment to a RAW file in Camera RAW, you automatically generate an XMP file. This is called a "sidecar" file, and by default is saved in the same place as the original RAW file. You can put it in other places, like in a central folder in the Camera RAW preferences, but the most common strategy is to save it with the original. If you somehow separate the file from its sidecar file (which shares the name but not the extension), or simply rename the RAW file without renaming the .xmp file, you're going to revert the settings to the "as shot" state when you open it in Photoshop.

The other place you see XMP is in the actual metadata. Open a file in Photoshop and go to File>File Info (*image A*). Here is the window you'll see; I've selected the advanced menu and highlighted the XMP Core selection (*image B*).

XMP is an effort by Adobe to standardize the format that metadata is written in. It's designed to be scalable—that is, able to grow to fit any foreseeable need. Like DNG, and intimately related to the DNG standard, it is Adobe looking forward, trying to lead the way to an open, universal method for writing data. At this point it is owned by Adobe—and as such not considered a "standard"—but has been embraced by much of the industry.

If you find this fascinating, I'd encourage you to start your further reading at the Adobe site dedicated to XMP: www.adobe.com/products/xmp.

If you don't, then just keep a few things in mind. If you've made adjustments to files, keep track of the .xmp sidecar files. Be careful when renaming files or you'll find you're back to square one as far as your RAW adjustments go, and if you're working with Smart Objects all the XMP data is built directly into the file for each Smart Object layer.

Book 1 Conclusion

There you have it. These elements—the RAW file, Layers and Masks—are the bricks and mortar of the Smart Object process and the basis for a big piece of the non-destructive workflow. (We will just call it the "Constructive workflow" from now on.)

The method I use to teach this stuff is pretty much the process I went through to discover it myself. First, there were the Kodak guys back in 1998 or so, talking about the RAW file. Back then we were trying to figure out exactly what was going on, and now, with the advantage of hindsight, I can see that manufacturers were doing exactly the same thing.

Of course, they were all processing RAW files, but Kodak figured that they could brand that processing as their own. Kodak was the first company to promote the RAW file as un-editable, admissible as evidence in court, and thus sell a bunch of cameras to law enforcement markets. They also understood the advantage of promoting their RAW processing software, Capture Studio, as a "perk" of buying their digital cameras. Soon, all the manufacturers we touting their RAW processing software, and other companies like PhaseOne and Bibble started selling RAW workflow software supporting many camera brands.

Next was my buddy Jim Gipe (www.pivotmedia.com), and his workshops teaching this brush-based masking method. Seriously, I went to about six of his talks before all the pieces of the process came together for me. It's not through any fault of Jim—in fact, his presentations are brilliant. First, it's because the process has a few very important steps, and if you leave them out, it all goes wrong. Second, it's because you really need to learn this while you're sitting at the computer. I've taught this to beginner classes at workstations and they pick it up almost immediately.

Then, it was one dumb little trick: The "pin register" move. You have two images that are exactly the same pixel dimensions open in Photoshop. You use the Move tool, but hold down the Shift key when you move one image onto the other. The two images snap to perfect pixel-by-pixel registration.

Suddenly I put it all together. If I work on a file with adjustment layers and masks, I can work with incredible control and repeatability. I can then go back to my rather cumbersome RAW process and duplicate those adjustments, and replace the adjustment layers with RAW files. The results were astounding. I had a student make a print from a Nikon D70 that had about 12 RAW layers in it, and seasoned professional photographers were looking at this print swearing it had to come from a large format negative. The file, by the time Chris was done with it, was over 500MB.

After a while I just dumped the first step—the part about using adjustment layers. I'd go right to the RAW file and hope for the best. Then

came Smart Objects. Suddenly I could get right to the RAW file and work with it at the same speed and efficiency of working with adjustment layers.

It's funny how this can slowly dawn on people. I had an online digital photo forum going at one point, and I was all about the Smart Objects. I was probably yapping about the Smart Objects for close to a year, on and off. One morning one of the regular guys got on and posted "I just discovered that you can use this new thing, Smart Objects, to get to the RAW file right in the Layer!!!" Heh. And I thought my teenager was the only one who doesn't listen to me.

There are a bunch of new features, and the Smart Objects do have a few interesting behaviors, but nothing we can't work with to make a slick process. Starting with a good core, let's flesh this out into a nice, complete structure.

BOOK 2:
THE SMART OBJECT CORE

Let's take what we've learned about layers and masks and put it into practice. We are learning our foundation skills, ways to combine them, and how to build our workflow.

This process is really like working with building blocks. We have several different components, pieces of our workflow process, and we can put them together in a few different ways. We're going to start off with some fundamental examples, but you'll see pretty quickly that "the devil is in the details." You must see how the components fit together before you know how you want them to fit together.

One more thing: As you start to explore this, there's the tendency to be timid and fall back on what you are familiar with. You might not find a way to do something you really like to do right away. After you get rolling with these tools, I'm fairly certain you'll find everything you need.

CHAPTER 5:

THE SMART OBJECT CORE

Let's dive right in.

The first step is to get your workspace set up, and all I really want to do here is to make sure the Layers palette is open. Go to Photoshop, Window>Layers and make sure that is checked (image A). I also like to pull the Layers palette off by itself—to do this, click the top of the palette tab, pull it away from the list, and into the main workspace. It should now look like this (image B). This keeps the workspace nice and simple. (In the words of Pablo Casals, legendary conductor, "Veddy clean; veddy veddy clean!")

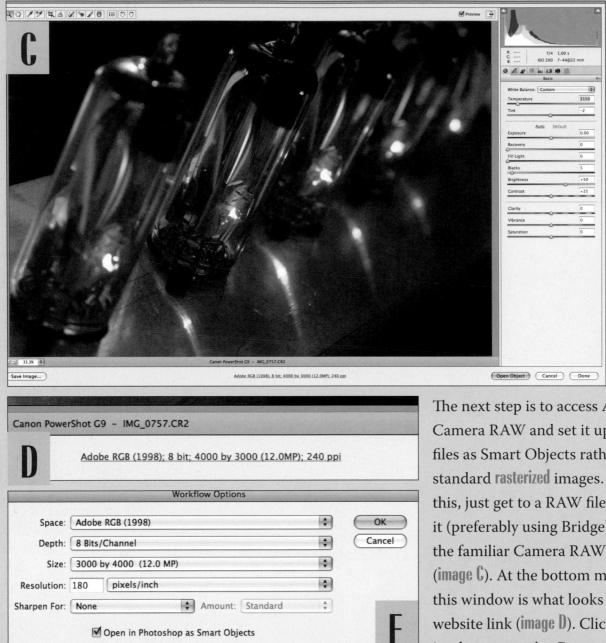

Canon PowerShot G9 - IMG_0757.CR2

D

Adobe RGB (1998); 8 bit; 4000 by 3000 (12.0MP); 240 ppi

Workflow Options

Space: Adobe RGB (1998)

Depth: 8 Bits/Channel

Size: 3000 by 4000 (12.0 MP)

Resolution: 180 pixels/inch

Sharpen For: None Amount: Standard

☑ Open in Photoshop as Smart Objects

OK
Cancel

E

rasterized: An image described in vector graphics format (lines and shapes) and converted into a raster image (pixels or dots) to output on a digital display or to store in a bitmap file.

The next step is to access Adobe Camera RAW and set it up to open files as Smart Objects rather than standard **rasterized** images. To do this, just get to a RAW file and open it (preferably using Bridge). Here's the familiar Camera RAW window (**image C**). At the bottom middle of this window is what looks like a website link (**image D**). Click it, and it takes you to the Camera RAW "Workflow Options" window (**image E**). Here you can specify some of the key processing preferences—specifically, the working color space you're asking Camera RAW to process to, the bit depth, the pixel dimensions, and the resolution of

your processed files. There's also a little check-box: "Open in Photoshop as Smart Objects" (image F). We want to check that little guy.

You'll notice, after you hit OK, that the "Open …" button has changed from "Open Image" to "Open Object." After you make your basic adjustments in the Camera RAW menus, hit this button and you'll kick into Photoshop.

Here's the workspace (image G) with your image, the Layers palette, and the background layer with this funny little icon on the layer. That, my friend, is the Smart Object (image H).

Now when you open a RAW file, it enters Photoshop as a Smart Object layer. The enormous power of this is revealed when you double-click the little Smart Object icon. Go ahead—try it. Bingo! You get right back to that Camera RAW window and the RAW file. We have simply set it up so we can edit the RAW file and re-edit it without having to get back out of Photoshop and start over with the original file. The RAW file is now embedded into our Photoshop file as a layer.

This is the nut of the process, and as the saying goes, "Mighty oaks from little acorns grow." Let's see what we can do with this.

Smart Objects: What We Can and Can't Do

Now this file is a RAW file, embedded in a Photoshop Image file. It has not been rasterized, which simply means it has not been processed from its original RAW state into the bitmapped state that most image files are once they are brought into Photoshop.

Can Do

Getting back to the Camera RAW dialog lets us do anything to this file that we can do to any regular RAW file, including major and minor image adjustments like color correction, contrast controls, exposure correction, grayscale conversion, hue and saturation controls, curve corrections, sharpening and noise reduction, and even dust spotting and camera calibration as we've seen in the previous chapter about Camera RAW.

bitmapped: An image described in terms of the specific value of individual pixels.

However, these are "global" adjustments—that is, adjustments that you apply to the entire image. We can also apply local adjustments (see page 46 for a discussion on the Adjustment brush and Gradient tool). As layers, our Smart Objects allow use of most of the layer tools we know and love (reviewed in Book One). I can use tools such as masks, opacity control, and even layer blending options to apply every control that I usually use in Photoshop.

I can also use most, if not all, of my filters, except for an astounding twist. Applying a filter to a Smart Object creates what's called a "Smart Filter" (not to be confused with "Smart Sharpen" in the sharpening filters menu). Check it out. I'm going to ask for a routine filter here, "Unsharp Mask." Filter>Sharpen>Unsharp Mask (image A).

Here's what I get: (image B). This is a "Smart Filter," and it also lets me re-edit the effect by double clicking the "Unsharp Mask" layer at the bottom. Try it, and you go right back to the Unsharp Mask filter. Also note, just above that layer is a mask icon labeled "Smart Filters." More on this later, too, but basically this is just a way to mask the filter you've made (image C). Crazy stuff!

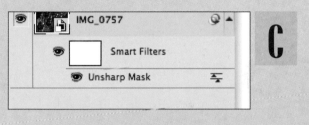

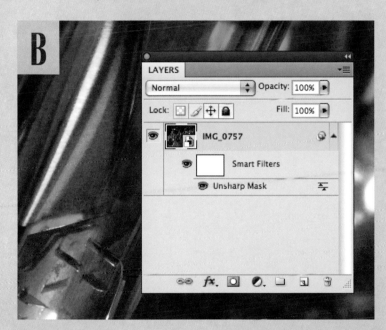

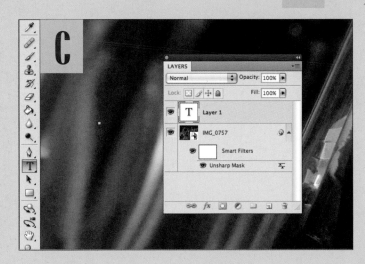

No Can Do

Here are a few standard processing steps you can't do with a Smart Object. (image A) You'll see that you don't get Liquefy, Vanishing Point, or Lens Blur. Most of your editing tools dealing with selection still work (image B), but all of the retouching tools do not, particularly the clone tool and the healing brush. (image C) Interestingly, the Type stuff you can work with, I guess because it makes a new, distinct "type" layer anyway. (image D) We can also resize our image, just the standard Image>Image Size works just great.

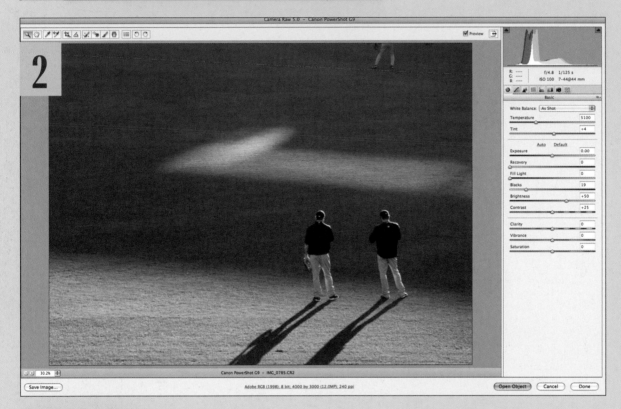

Examples: A Standard Workflow

Let's get right to it with a simple example of processing a RAW file as a Smart Object.

I've selected my image in Bridge and double-clicked to open it. As a RAW file, it opens into Adobe Camera RAW. Here's how yours may look (**image 1**).

The first thing I do is click on the Workflow Options link and set it to Adobe RGB (1998). For native pixel size, I like to make the resolution match up with how I like to send files to my printer, so I set it to 180ppi, and check the box next to "Open in Photoshop as Smart Objects." Hit OK and make the basic image adjustments (**image 2**).

I choose "Open Object," and it processes the RAW file and brings it into the main Photoshop workspace for me to mess with. I want it to look a bit better, so I double click the Smart Object Layer icon and get back to the RAW window to make some more adjustments. I think this looks too dark so I just boost the "Brightness" slider a bit, and hit OK (image 3).

The following steps are what I usually do to create fast work prints immediately. I use work prints for a number of reasons, but mostly because it helps me really see my results. As one of my students once said—regarding using the monitor to try to "see" the final print—"You're staring into a light bulb!"

Still working with my Smart Object, I hit File>Print (image 4) and get my standard Adobe Print window (image 5). Here you need to make all the usual printer-related color management moves, but because I haven't finalized the size, I also use this window to control our size (image 6). I turn the paper horizontally and choose 7.5 inches (19.1 cm) in the "Width" window so my image will fit on 11-inch wide

7

8

viewing light: Viewing light literally means the light under which you view a final print. If you are printing for a specific use, such as hanging in a gallery, you should view test prints and final prints under the same lighting conditions to determine optimum color results.

(27.9 cm) paper. I hit "Print," access the Epson printer driver settings, set the paper type, and turn the printer's color management off.

When my print comes out of the printer, I take a look at it under my **viewing light**. I guess I went a little overboard with the Brightening, so I'm going to go back and give it a little nudge. Double-clicking the Smart Object icon brings me right back to Camera RAW, and I push the Brightness back down a bit and run another test print. I do this until I'm satisfied I have the look I want for the image.

The last step is to apply Unsharp Mask, and I do that after I've decided on a final size. I want to see this image at 11 x 14 inches (27.9 x 35.6 cm), so I go into Image>Image Size and see what I have (**image 7**). This shows me I that the image is going to print bigger than I need at my 180ppi resolution, so I resample it down to the dimensions I'm looking for. I make sure "Resample Image" is selected, and then enter 14 inches (35.6 cm) into the width. The height calculates to 10.5 inches (26.7 cm).

I look at the pixel dimensions information, and see that I've gone from 34.3 megabytes (MB) down to 13.6MB. Because I'm resampling down in size, I select "Bicubic Sharper" as my resampling method (**image 8**). (When sizing up, I select Bicubic Smoother.)

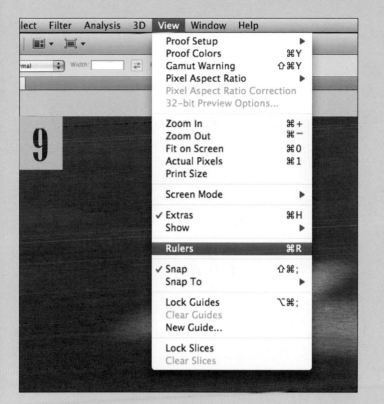

the image at the approximate printed size, but it is usually a little off. I use the ruler scale on the edge of the image window to see if I need to zoom in or out a bit.

Once I size the image, I go to Filter>Sharpen> Unsharp Mask (image 12). Now I can go into

Unsharp Mask and make adjustments, referring to my image (displayed at a size close to the actual print size).

Now I have to use Unsharp Mask intelligently to give my image just the right amount of sharpening. I want to give it some snap without making it too obvious. The first and most essential step in this process is to view the image on the monitor at its print size. (First, go to View>Rulers and make sure it is checked. This helps you gauge how the image is being shown on the display (image 9).)

Select the Zoom Tool (image 10). At the top of the screen are some Zoom Tool buttons—in particular, "Print Size" (image 11). This displays

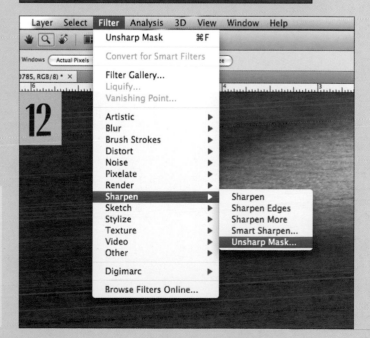

Unsharp Mask: A sharpening filter in Photoshop used to enhance and amplify the edges in an image (the differences in value between neighboring pixels) by increasing the perception of sharpness in the final image. Unsharp Mask gets it's rather misleading name from Offset Printing techniques to accomplish the same effects before digital prepress production.

I can see exactly what the Unsharp Mask is doing and how it will look when it's printed (image 13). Make sure "Preview" is selected and look at the image itself (not the "100%" view in the Unsharp Mask window) to gauge how much or little Unsharp Mask to apply. Once I have it where I like it, I hit OK, and get a Smart Filter tagged on to the Smart Object layer.

In short:

Step One: Scale to final size.

Step Two: View at print size.

Step Three: Apply Unsharp Masking.

Again, I make a work print. This time, however, my image will fit on my paper without using the scaling in the Print window, so I can just leave that at 100% (image 14).

Now I look carefully at how the sharpening looks. If I can see the slightest hint of "haloing," I go back to my Unsharp Mask, double-click the "Unsharp Mask" layer, and turn that baby down (image 15). Then I make another print to check it.

Now that I have the image where I want it, I save it and—most importantly—save the image with the active layers. I can do this as a TIFF or a PSD file; it doesn't really matter which. Both formats save the layers, and I am accustomed to TIFFs, so I just go File>Save as>(filename).tiff (image 16). Make absolute certain you have the "Layers" box checked (image 17).

Typically, this is just the start of finalizing an image. I often save the prints, put them up on a board (or the refrigerator), and look at them for a while. If I want to make changes, I can easily go back to my file just as I left it and get complete access to the RAW file to make any needed edits to the original data.

There are a whole host of side roads we can take from there—this is just the beginning. Hold on to your hat!

haloing: This is considered a negative effect produced by over-sharpening an image file. In an effort to make an image look sharper by increasing local contrast along a tonal edge, an image sometimes produces colors outside the original image tone range called a halo.

Sharpening—and Unsharp Mask in particular—seems to spark complex debates. My sharpening strategies are simple, effective, and very specific to digital photography, though not necessarily for scanned images. You may have noticed my settings in some of the figures shown here.

A

B

C

It is crucial that you have sized your image to its final dimensions and resolution. Apply Unsharp Mask as a last step in your workflow—just before you print. Here I'm printing to an 8.5 x 11 inch (21.6 x 27.9 cm) sheet of paper (image A).

Turn the workspace Rulers on (View>Rulers). Make sure it is checked, or use the keyboard shortcut <Command+R> (image B).

You should view the image at "Print Size," not "100%." (Select the Zoom tool; the button for Print Size appears in the toolbar to the right (image C).) You see the image at approximately the size it will be printed. Viewing the image at print size ensures you will not over- or under-sharpen for the dimensions

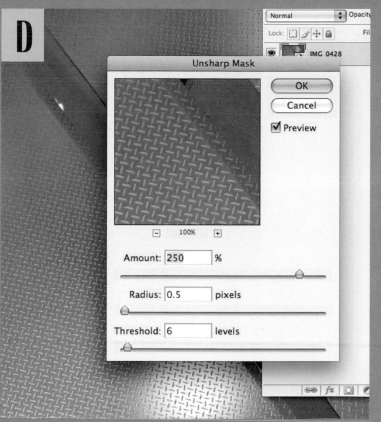

Apply Unsharp Mask to your image. First, lock the Radius setting to .5 pixels. This departs from Photoshop's default pixel setting (1), and means you must compensate by increasing the amount. That is why my Amount might seem high—anywhere from 150% to 350%. The Threshold setting feathers the effect back by adding more "levels" or gradient to the increase in local contrast—the contrast between pixel neighbors—which is what makes the image appear sharper. I put this between 2 and 7.

These settings correspond to the size of the image. A bigger image needs a higher "Amount." A smaller image requires a smaller Amount. The Radius is always at .5 pixels. The rationale behind this is simply that this produces a nicer sharpening effect with digital image files than other settings I've tried. It gives you a subtle, crisp edge and avoids the dreaded halo of a rough sharpening job.

you are printing to. Make sure your resolution is set correctly in Preferences (see Zoom Tool Geekzone on page 40).

NOTE: "100%" uses your screen resolution to take a stab at the right size, and depending on the screen resolution, the image could display at something other than true size.

Now select Filter>Sharpen>Unsharp Mask (*image D*).

With the Preview checkbox selected, look at the main image in the Photoshop workspace, not the Preview screen in the Unsharp Mask window, to judge the effect. Now you can make your adjustments intelligently.

Here's a particularly hideous example of that halo effect (*image E*). Look at the black line and the lighter areas bordering that line. They taper off to the normal tone, a fair distance away from that line. This is what we'd prefer it look like (*image F*); nice even tones leading up to some hard edges.

In case that's not enough to spark a heated exchange on a digital photo forum, I have one more thing to add. I rarely apply sharpening over the entire image anymore. It seems that there are very few instances where you want to sharpen everything. In the first place, Unsharp Mask needs an edge, and if there is no edge it won't have anything to work with. Out of focus areas or areas of tone or color without an edge may get some unpleasant effects, most often an undesired enhanced noise or "grain." In the second place, it's just something that isn't what I want in every area of the image. In a portrait, for example, I'll only sharpen the eyes and the hair to give the image some snap. I almost never sharpen the skin or background. Of course, I use my masks to control this, but you saw that coming, right?

CHAPTER 6:

ADDING LAYERS

The Smart Object Core:
Adding Layers

The example at the end of Chapter 5 works well for images that don't need spot corrections like burning and dodging, but suppose I want to make some areas of my image darker, by "burning them down." If you don't know any better—that is, if you haven't read my other books—you may just use the Burn or Dodge tool. That's not a great solution, because it is both destructive and linear. Those tools make edits that are one-way changes. They delete or alter the original data. Plus, once you make those edits you can only go backwards by using the History palette—an option that goes away once you save and close the file.

Another solution is to use an adjustment Curve layer and mask the spots for correction. This is a better solution, but a Curves adjustment is still destructive. That is, you are not putting any new information into the file, you're simply

burning: Named for the traditional darkroom technique, the Burn tool in Photoshop darkens pixels.

dodging: Also derived from the traditional darkroom, the Dodge tool in Photoshop lightens pixels.

messing around with what is there. You can chop up a file pretty badly with adjustment layers without even realizing it.

The best solution is to use Smart Objects, because I can always get back to my original image information. Here's how we do it.

Bear with me here—I'm going to lean pretty heavily on my Layers and Masking skills. For a review of that, check back to Chapter 3 on page 100. Honestly, once you get this routine down, it is really easy. As with all Photoshop routines, the process is branded into the brain by repetition and simplicity.

Here's an overview: I want to make a new layer, so I can adjust it to be darker. Then, to select only the areas I want to go darker, I'll mask the

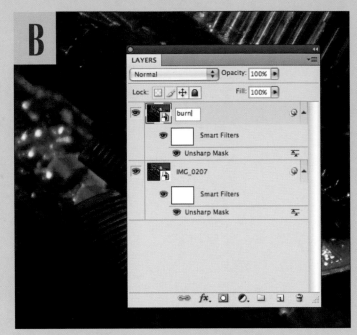

layer and use my brush tool, painting white on my black opaque mask, to reveal the areas of my darkened image. Ready?

First, I want to copy my Smart Object layer, but I don't do that by just dragging it to the "Create a New Layer" icon on the Layers palette. That will indeed create a copy, but the copy will be a perfect copy, linked in every way to the original. If I make the new copy darker, the original will go darker too. To get past this, I must make my new Smart Object using Layer>Smart Objects>New Smart Object via Copy (image A). (If you're really observant, you'll see I've made <Command+Option+C> my Custom Keyboard Shortcut for this menu.) This creates a new, but unlinked, Smart Object. Note that it also makes a copy of the Smart Filter layer. I rename this immediately so I don't lose track of what I'm doing; I double-click the label and name it "burn"

C

Preview

R: ---
G: ---
B: ---

f/3.5 1/30 s
ISO 200 7–44@22 mm

Basic

White Balance: As Shot

Temperature 3100

Tint +8

Auto Default

Exposure –0.95

Recovery 0

Fill Light 0

Blacks 5

Brightness +50

(image B) Now, I double-click on the new Smart Object icon and get access to the RAW file. I pull the Exposure down, click OK, and it rebuilds the layer (image C).

Custom Keyboard Shortcut: User-defined keyboard shortcuts, found here in Edit·Keyboard Shortcuts. See page 179 for more.

This makes a global change, darkening everything. I want to select only some areas, so I make a mask (Create Vector Mask) with the little button at the bottom (image D). I select the mask (just one click), and invert it to black with the keyboard shortcut <Command+i>. I paint onto the now-black mask with a white paintbrush to expose the dark areas through the mask, effectively burning those areas darker but adding RAW image data (image E).

Again, review it in Book 1 (page 100), and keep at it. The big point to take home here is that this incredibly powerful process of layering and masking can be used not only with basic adjustment layers, but with everything about Smart Objects too! We'll be touching this again throughout the rest of the book.

Placing Layers

Another way to add Smart Objects is the old "Place in Photoshop" trick.

When I first started working with Smart Objects, the only way to get a Smart Object layer into an image was to go from Bridge and go File>Place>In Photoshop. There were a couple of tricks to that—one being that you had to have a target file open in Photoshop so Bridge knew where to "Place" the file. If you had done all that without a target file, nothing would have happened.

XMP data: XMP data is an Adobe-created standard for storing and processing the proprietary metadata attached to an image file.

Somewhere along the way, Bridge got a little smarter, and now if you do that, you'll just get the file opening as a Smart Object (as one layer), bypassing the Camera RAW control panel. It will work with whatever the previous XMP data told it to use.

However, once I have a file open in Photoshop, Bridge does exactly what it used to do. It "Places" the file into the open file, and allows you to

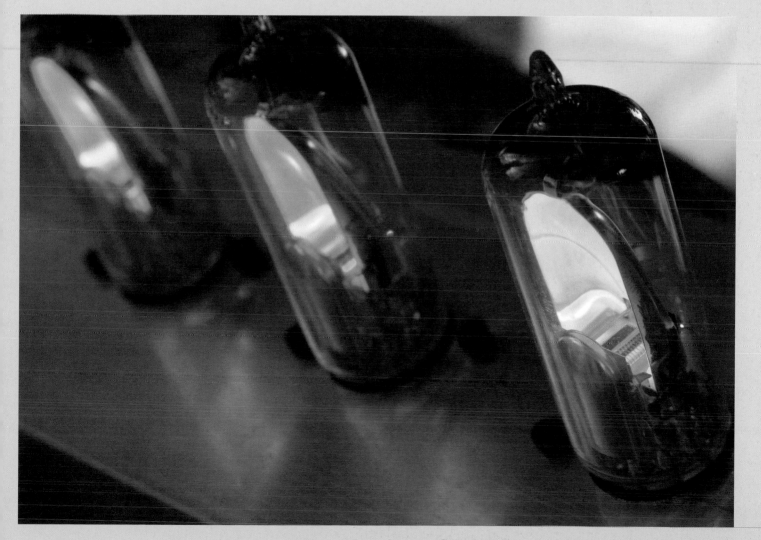

move it around, if you need to, before it is "set." (It does allow you to get at the Camera RAW window, by the way.) It gives you an X over the image, and if you double-click within the X it renders the Smart Object (image F).

I know this is a pain—so much so that for a while, Photoshop users created Actions you could download to it automatically. Then Adobe adapted and let the user direct Camera RAW to do it ("Open in Photoshop as Smart Object" in the Workflow dialog; see page 55). There are still times you might want to use this, though; in general it's going to be when you want to add a completely new image rather than just copy the existing image layer.

Here is an example: Suppose you're messing with High Dynamic Range (HDR). You take one exposure and set that up as your target. You take an exposure that is as much as three stops more exposed (overexposed, according to the camera), and place that as a Smart Object Layer. Then you take the shot you made, this time three stops underexposed. Snap! You have one image with three layers, covering maybe 20 stops of dynamic range. You then use your masking skills to reveal the detail in the areas you want. (More on this on page 242.)

Another example: Suppose you want to combine images—put a nice sunset behind a boring building for instance. Open your target file in Bridge, place it in Photoshop (File>Place>In Photoshop), move it to where you need it, and double click to set it. Then adjust it with the layer/mask workflow we've talked about.

Photoshop Masks is a huge subject. I'll dive into this with a bit of depth, but in no way will I cover the subject thoroughly. My experience throughout 30 years of photography has been in the darkroom with a little printmaking thrown in for good measure, so the tools that speak to me in Photoshop are those that feel most like what I know from the traditional darkroom. I am also interested in what I call classical photography—that is, photographs that feel true to traditional photography. I'm not very interested in making composite images or using clever manipulations to create otherworldly images; I'm more interested in staying true to what the camera captured and what I saw when I snapped the shutter.

The way I understand the Mask is through my darkroom work and my experience in pre-press and printmaking. The basic root of the mask can be illustrated with a silkscreen, which is nothing more than a stencil. You cut out the areas of a stencil and the ink is pushed through onto the paper. When you make silkscreens (or serigraphs, to be precise) there are only have two kinds of areas—full ink and no ink—that result in the wonderful, hard-edged forms and tones of the prints. "Gray" areas on a silkscreen, areas of partial ink coverage, are created by small, hard-edged areas of solid colors—dots, if you will. Hold that thought and let's take it to the darkroom.

In the darkroom, the negative is in an enlarger. The enlarger is simply a projector that shines the negative's image down onto a light-sensitive surface—usually paper. The light hits the paper and the chemicals react to the light and turn the paper black or gray based on the amount of light, creating the image. The negative is just like the silkscreen stencil but with more flexibility; we can make gray areas, not just black and white. If the film only lets a little light through, you get gray. (Stay with me here.) In the traditional darkroom, the negative acts like a mask does in the digital darkroom, controlling where and how much light hits the paper, and therefore how light or dark it is.

Take it one more step. In the traditional darkroom I can "burn" or "dodge" areas of my print to make them darker or lighter. By adjusting

the light applied to the basic negative image, I can vary the tones it creates while keeping the image intact. I can make a shadow lighter or a highlight darker. This burning and dodging process is like applying a second mask, fine-tuning the tones that the first mask—the negative—has made.

Let's bring this back to the layer workflow. The basic image layer is nothing more than a negative. That is the source of the picture and the image I start with. I then add an adjustment (whether an adjustment layer, or in our case a Smart Object). I mask the adjustment and use a selection of that mask to control how much of my adjustment is applied to the image (refer to Making the Mask with a Selection on page 114). Again, think in terms of a stencil. I make a darker image, and cut away part of a stencil for it, so the darker image shows through in only a few areas.

Let's move on to how to do basic work with masks and where to go from there.

Creating Masks

I'm going to start with an image, and I'd like to burn down, or darken, some areas of it. You can review in detail the setup and masking steps on page 107; we'll quickly go through them here. Here is my source image (image A). First, I create a second layer (Layer>Smart Objects>New Smart Object via Copy) and then adjust it so it

is darker (image B). That adjustment is applied to the whole image, which I don't want. I only want to apply this darkening to certain areas of the image. I select those areas with a mask.

I click the little "Add Layer Mask" button (image C) and get a mask, shown as a white rectangle next to my image icon (image D).

The mask is white, which indicates the mask is transparent. I want to start by making the mask opaque, blocking everything out—I do that by making it black. The quick way to do that is <Command+i>, or "Invert."

NOTE: Make sure you have selected the mask before you make any changes to it, such as inverting it to black.

Once you invert the mask to black, it appears as though the darkening adjustment I just did has gone away. It hasn't gone away; it is simply being covered up with the black mask.

Now I need to edit the mask—that is, I select what areas of the mask will allow the darkening adjustment to show through.

The method I like most is using the Brush tool to actually paint on the mask. I like this for a few reasons: First, it gives me a lot of control in what areas I select and the ability to change the mask later. Second, it is just like the process I've used for 30 years—burning and dodging in the darkroom.

I set the foreground color to white, so my brush is painting white. I'm also setting the "Mode" to "Normal," and the opacity and flow to 50% (image E). This is just a starting point; I may turn this up or down later, but the upshot is that I'm not actually painting white, I'm painting a "feathered back" white (in effect, a shade of gray). The more I paint over the area, the whiter it will get, meaning the more transparent the mask becomes.

Here's what my image looks like after I've darkened the corners (image F). And here is what my mask looks like (image G). If you want to see a good illustration of how the mask is a selection, hold down Command and Shift and click your mask. This shows the marching ants around the areas of

the image you're selecting to show through (image H). Want to see just the mask? Hold Option and click the mask (image I); click it again to go back to the normal view.

Creating Masks with Selections

Here's the secret of masks: It's nothing but a channel. Go to Window>Channels, and there's the mask as a channel (image J). We're not going down the "Channels" rabbit hole, but it is helpful to understand that a mask is a separate entity. Let's go into other ways to make the selections for a mask.

A useful technique for making masks is to first select an area of the image and then make the mask. The mask is then generated using only that selection. Exploring selection techniques can give you numerous methods for making masks quickly. The magic wand, lasso, and other selection tools do a great job, but there is one in particular that I use frequently to control the selections, and that is "Color Range" (image K).

I start by making a new Smart Object, and then go to Select>Color Range. Here's what I see (**image I**). I've picked "Sampled Colors" and clicked on my yellow highlight areas. I can adjust my "Fuzziness" to feather my selection (make it bigger or smaller, softer or harder). I can add or remove selections with the +/- eyedroppers (**image M**). Once I have what I want, I hit OK and it makes the selection. Here's the result, showing the ants again (**image N**).

NOTE: Make sure the "Auto Select" button is turned off or deselected (image O).

Now I make the mask using the button at the bottom of the Layers tab, and here's the selection I get (image P). I can fine-tune my colors in only those areas—making the yellow darker or

lighter or changing the hue completely—without changing any other areas in the image. Just to show this clearly I've made the lights very golden (image Q).

Suppose I want to modify this mask— I'd like to make it a little softer. I click the mask while holding down Command and Shift. This gives me the marching ants. I go to Select>Modify> Feather (image R) and get this screen (image S). Now I can soften the edges a bit and make a new mask. (Delete your old mask, hit the mask button on the Layers tab, and create a new, feathered mask.)

Take one more look at the Select>Color Range window. Notice you can pull down a list of

selection criteria; one of the most helpful is the "Highlights" and "Shadows" choice (image T). With this you can quickly grab the brightest or darkest areas and use the mask on your Smart Object to bring those areas into a printable range.

Finally, there is the "Out of Gamut" selection (images U & V). Don't get too excited about this; this will only work when you're working in CMYK—something only done in the prepress world, not with photography. The out of gamut colors it selects correspond to the default CMYK you've picked in the Color Settings you've picked. See the Color Management Settings discussions on page 32 for what I feel is a more solid solution for digital photographers.

I limit myself to a few good tools. As my buddy Bill Gallery says, "We don't need more blades on the Swiss Army knife, we need fewer, better ones." This method of selection—and generating a mask from the selection—is powerful, simple to use, and adaptable to many tasks, so it's the one I use. You may prefer a different one out of the huge array of tools available in Photoshop, so be my guest. The beauty of the Layer/Mask/Smart Object process is the flexibility to use whatever you want to make the mask, and go from there.

Color Settings: Photoshop allows the user to determine the specific policies for handling color management by using the "Color Settings" dialog. This allows the user to specify the preferred Working Color Space, the color engine, and the protocols used in handling color management decisions in cases of missing, or mismatching embedded ICC profiles in files. These Color Settings can be synchronized throughout the entire Suite of Adobe products.

CHAPTER 8:
WORKFLOW STRATEGY

Red meat isn't bad for you
Fuzzy green meat is!

C2-H10759

Developing a Consistent Approach

The Smart Object workflow is so flexible and powerful that I use it for everything, but there are a few habits you have to get into that differ a bit from the standard process.

The Source Layer

There are a few basic principles at work in the Smart Object workflow, one being that when you make your Smart Object copy, you are copying the entire "package" in that layer. If you've made adjustments—added masks or filters—you copy all of those attributes along with the basic Smart Object. This makes it very important that you set up the source layer, or the layer you use to make copies from, as the "smartest" Smart Object. In other words, set up a layer while keeping in mind that you will make several copies of it and so you have what you need included at the outset.

The other thing that you have to keep in mind is what I call the Rosenholtz-Sanchez effect. Discovered by two of my students, this is the fact that Smart Object layers seem to compound filter effects and other layer adjustments made on a Smart Object layer. When you work on a Smart Object and apply edits to that object—including masks and filters—it essentially creates a complete package in that object. If you use that Smart Object to make another using Create New Smart Object via Copy, it creates the new object including everything from that source layer.

177

Example: Unsharp Mask Adjustment

As an example, look at an Unsharp Mask adjustment. Where and when you make an Unsharp Mask layer is very important. Remember, when you duplicate a layer with a mask, the mask appears to compound the adjustment (See The Rosenholtz-Sanchez Effect, page 190).

In a standard file, I make a basic Smart Object layer and an Unsharp Mask Smart Filter on that right away. Then, as a standard practice, I am going to make a "burn" layer (darker) and a "dodge" layer (lighter). Finally, I might make a "spot color" layer to make small local color

corrections in a few areas. This has become a habit with me, so I automated the whole process using Actions.

My basic approach is to start with that first layer and its filter, and make my copy layers immediately. That way I'm propagating them all from the initial Smart Object with no added adjustments or filters. Then I'll go in and work on what needs to be adjusted.

Actions: Actions allow the user to record and "play back" a sequence of Commands whenever desired. Actions are most often used for repetitive tasks (such as saving JPEG files from TIFF originals and closing the original) or complex tasks (such as multiple-step sharpening techniques) which are both repetitive and complex.

Open your file as a Smart Object (image A). Now, add your filter (Filters>Sharpen>Unsharp Mask), and set the Unsharp Mask settings close to what you think they need to be (image B). (This is based on experience. Most people use a pretty standard setting and don't alter that too much. It's not critical, either. You can always go back and change it—remember, it's Smart.) Hit OK, and this becomes the "source" layer (image C).

Now we'll make our working layers. If your keyboard shortcuts aren't set up for this, go to Layers>Smart Objects>New Smart Object via Copy (image D). If your keyboard shortcuts are set up (see page 235), just hit whatever you've designated as the shortcut to make the copies. I've set mine up already, so I hit <Command+Shift+C> and make three more

E

copies. Right away I'm going to label them. Double-click on the name of each layer, and rename them accordingly. Here's my basic starting point (image E). I create four layers: a source, a burn, dodge, and spot cc (spot color correction) layer; then I turn off all the Unsharp Mask filters except the first one and I'm ready to start working.

I go to my "burn" layer, and re-open the Smart Object. I bring the highlights down, using the Exposure slider, and bring my Brightness down. I hit OK, and it builds in a darker layer, holding the highlight detail (image F). I use the masking

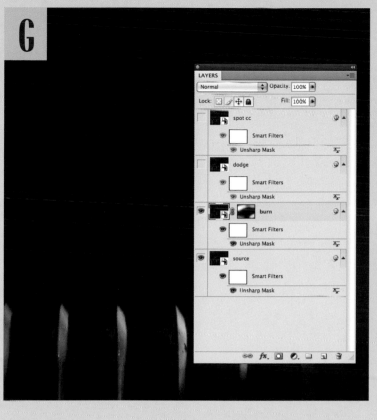

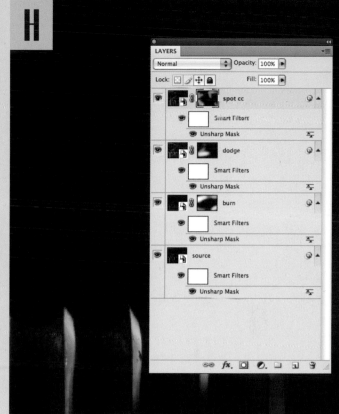

tools to select the areas where I want to apply this "burn," and work on it with the upper layers turned off (image G).

NOTE: Turning the higher layers off is very important—if you don't hide the upper layers from view, you can't see the layer you're working on.

I move up to the next layer, turn it on, and make the adjustment. Move up, adjust, and mask for each layer. Here's what this finally looks like (image H).

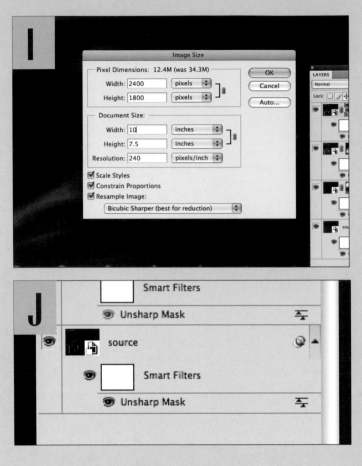

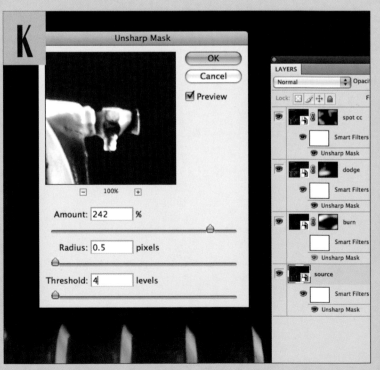

the same adjustment there, too. Now I've got to watch out for the Rosenholtz-Sanchez Effect. I'll have two layers, with the same filter, both visible. I can simply go into the overlapping layer and make the same adjustment, or one that is less aggressive, and I'm good.

There are some pretty nifty ways to manage Smart Filters, which we will go into later—like copying them—but for now, it's probably best to just try this basic strategy to get your foundation of skills down.

Finally, this is what my layers look like (image K). This shows the Unsharp Mask filter set up on both the source layer and the spot cc layer.

Assuming I'm done and want to make my final prints, I need to check my Unsharp Masking. I set up my Image Size, go to my Zoom Tool and view the thing at "Print Size" (see page 40) and recheck the filter appearance (image I). Remember to go to the source layer and double click the "Unsharp Mask" filter to get to the controls (image J). I apply the Unsharp Mask settings (see page 152 for Sharpening Strategies) and hit OK.

Here is where it can get dicey: If I have done some "double correction"—that is, lightened one area and then spot cc'd it—then the layer above (the spot cc one, in this example) is sitting on top of what I just did, so I must make

Smart Object Cloning and Healing

As we've seen, the process of building layers of Smart Objects on an image adds multiple layers of essentially opaque images. They are generally masked so you can see one layer coming through others on top, but this sets up a few issues when you're thinking about retouching—in particular, using the Clone Tool and the Healing Brush (image A). There are a couple of solutions, and I'll admit that this is one of the somewhat "inelegant" parts of this workflow. Camera RAW in CS4 now gives you a Clone and Heal tool (keyboard shortcut) that does pretty much everything you can do in the main Photoshop workspace, but in a slightly different way. This is the first place we'll address spotting.

Here's what that looks like (image B), and it's pretty sweet. When you select the Retouch Tool, you get some settings at the top, and the "Radius" usually starts at 1. Bump that out to around 10, and then click on a piece of dust.

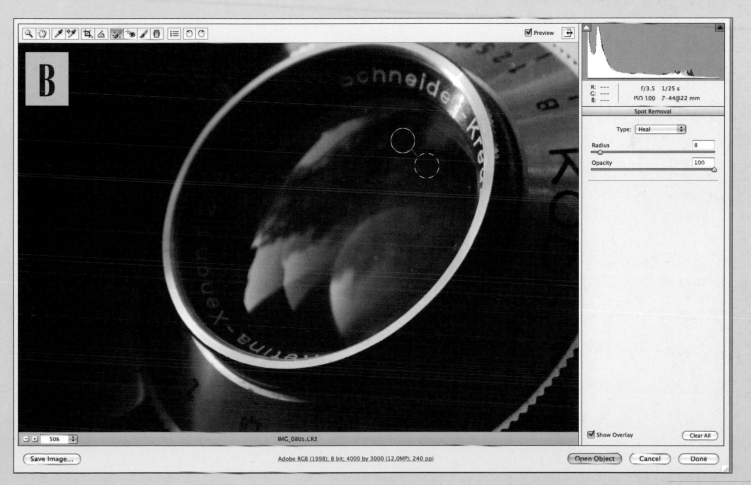

C

R: ---
G: ---
B: ---

f/3.5 1/25 s
ISO 100 7–44@22 mm

Spot Removal

Type ✓ Heal
 Clone

Radius 8

Opacity 100

You'll get a circle showing a "target" area that is being retouched, and you'll also get an automatic "source" selection. You can then go in and drag both of those around, and even grab the edge of the circles and make them bigger and smaller. In the little window that says Heal, you get a pulldown that gives you a Clone option too (image C). These work exactly the same as in Photoshop, but again, we're working on the RAW file.

Heal and Clone Tools: These tools are used for localized retouching of images, by either a fairly simple, yet controllable "Copy and Paste" (Clone Tool) move, where the user copies small areas of an image to paste into areas needing retouching, to very sophisticated blending and sampling of an area, the surrounding background of the area, and the texture from a sampled area (Heal Tool).

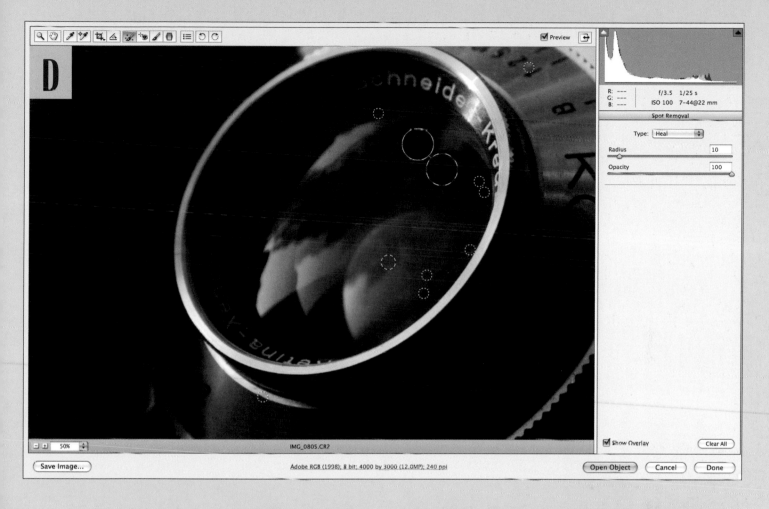

Here's what my (very dusty) chip photo looks like after a little spotting (image D). The circles showing the source and target samples are called the "Overlay," and if you find it distracting you can hide it by clicking the "Show Overlay" button. I usually toggle that on and off to get a grip on how it all will look, without the distraction. This just turns the circles and lines off, but leaves the actual retouching.

Often the automatic features of these tools work pretty well to start with, but I almost always go in and push things around manually.

It's a different approach to an established skill for most digital photographers familiar with Photoshop, so it does throw some people. After a bit of practice with it, however, most people can do everything here that they can do with the Heal and Clone tools in Photoshop, and in a way that lets you go back and re-edit. Yes! This gets saved in the Smart Object Layer, and you can go back to it later and re-edit it just by opening that Smart Object.

This feature was probably intended primarily for dealing with dust on the camera sensor. You can, in fact, apply this pattern of retouching to whatever images you need to through the **Synchronize** button. Here's a view of the window you get when you're working on several images, you've done some spotting, and you've hit the Synchronize button after selecting your images (**image E**). You can see this even gives you a "Spot Removal" preset under the Synchronize pulldown menu.

Now that we can see where we clone and heal spots, the question is, when do we do it? My answer is to go in and spot on the very first Smart Object Layer, because you're going to use that layer to make all of your burn, dodge, spot cc, and other layers. The spotting you do needs to propagate through all of those layers, so if you build it into the source layer, then it will translate to each additional layer. If you don't, then you'll have to scrutinize every single layer you work with to see if there are spots, and re-do your retouching for each layer.

The "Merge Visible" Gambit

There have been very few instances where this doesn't work well (which is usually due to the user "not liking" the Camera RAW tools), and you need to actually do some retouching to a layer in the main Photoshop workspace, not in Camera RAW. Here is an option—not a great one, but an option that gives you at least some repeatability and control, maintaining the Smart Object layers. Here's how it works.

The idea is to make a **rasterized** layer—that is, a layer that is no longer a Smart Object. I can do that by flattening all the layers, but that dumps

out all of the Smart Object information and is not something you can reverse once you do it. What I'm going to do is use "Merge Visible" to make a new layer comprised of all the layers underneath.

Here's my image with all my usual layers (**image F**). Be certain you're on the top layer (the active layer is highlighted light blue). Now, this is very important: Before you do anything push and hold, the "Option" key.

gambit: In chess, a gambit is an opening move—that may seem minor or even in error—that sets into action a series of events ultimately working in the player's advantage. In general use, it's an opening remark, action, or process that is a calculated risk to gain an advantage through a sequence of related results.

Go to the palette options button (image G) and slide down to the "Merge Visible" selection. Here's what you get (image H). This is a layer comprised of all the layers and their additions below—layers, masks, filters, the whole thing—all in one layer. Note, however, that it is not a Smart Object layer. This means that you can do a few more things to it, but once they're done, there's no turning back. This also means that, should you decide to go back and make adjustments to the layers below the "merged" layer, you have to go back and make a new "merged" layer for those adjustments to be seen. For this reason, this step should be done as an absolute last step in the process.

As I've said, this is somewhat inelegant, a little against the flow of our system, and I'm guessing soon to be improved as future versions of Camera RAW and Photoshop emerge. I'd encourage you to push the tools inside of Camera RAW as hard as you can and really see what you're able to do with them before resorting to this "workaround."

workaround: A strategy to overcome an error or missing sequence in an application or a process. If an application fails to operate normally, or if it does not do a specific task (by design) that a user needs, a workaround is a way to bypass or overcome the application to achieve the desired result.

We've talked briefly about what the Rosenholtz-Sanchez effect does, but we haven't talked about what it really is.

There are a couple of ways that Smart Object Layers seem to compound an adjustment. Basically, this applies to copying a layer on which you've applied an adjustment and a mask.

If I start with a layer, then make another Smart Object on top of it, I'll get a solid, self-contained layer that has edits that only apply to itself (*image A*). In this case I've adjusted it darker to burn down the perimeter. I make a mask and "burn" down the areas I want. If I copy that layer now, it will appear to compound the adjustment, making it darker still. If I keep copying the latest layer (the top layer), it just gets darker and darker. Here's what three iterations of that looks like: (*image B*).

It's simple. Each "Smart Object via Copy" move uses the source layer as its starting point and applies that to the overall image. The moral of this story: Be careful of which Smart Object you copy and how it is propagating adjustments. To be safe, I usually copy only from the first – or Background – layer.

Something is fishy here, though. If you create a straight, unmasked darker Smart Object layer and make several copies on it, you'll notice it doesn't get any darker. If the edits get compounded, then why isn't this compounding here? Go ahead, try it (image C). This example shows a basic "dark" move, and is copied a few times. The end result is no darker than the first edit. Why?

This is why: The "Smart Object via Copy" move compounds the mask, not the edit. Here's a basic image, and a very dark adjustment on top (image D). Now I'm going to hold that back by turning it off for the moment and make a copy with a mask, using my standard 50% flow and 50% opacity settings. I'm just going to hit it lightly. Here's what it looks like (image E). I've named it "unmasked adjustment" to keep it straight.

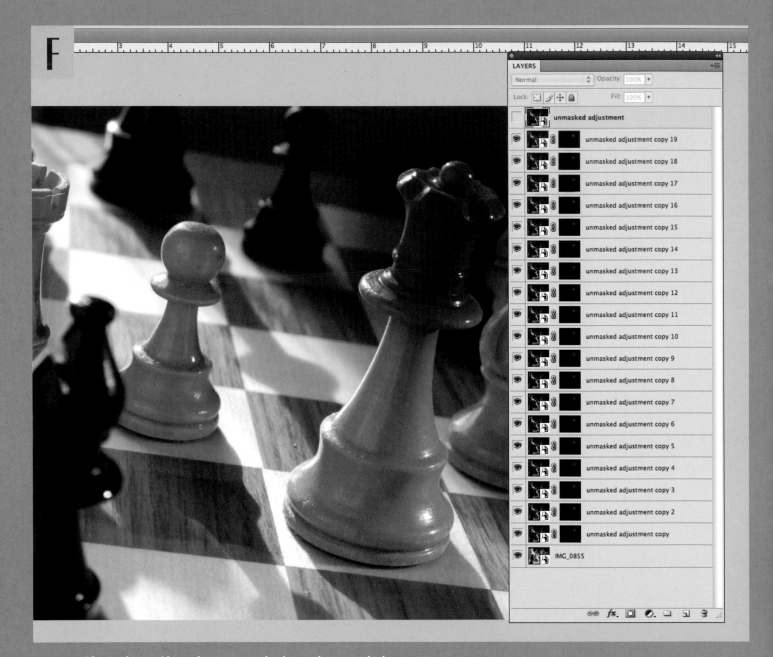

After 19 layers, I have the same tonal value as the unmasked layer. Here's the 19th layer (*image F*), and here's the dark layer moved to the top (*image G*).

Each "Smart Object Layer via Copy" move compounds the mask, moving it to more and more transparent. It basically is like painting on it with the 50%/50% brush repeatedly—19 times in fact—until it shows 100% of the Smart Object it's masking.

Want to see something funny? This is what my 19 copies looks like (image H), and this is what it looks like when I hit my

mask 19 times with the same 50%/50% brush setting (*image I*). The spread of the mask is a little different, but the density of the edit is the same.

When you're working with Smart Objects and Smart Filters in a masking workflow, it feels like there is some magical mechanism going on and the edits, filters, and adjustments you're making can get out of control.

Keep this in mind: It's not magic; it's the mask.

BOOK 3:
ADVANCED TECHNIQUES

I have a theory that most photographers are frustrated musicians. It's a personal theory, but somehow the talents and temperaments of photographers and musicians seem to have similarities. One is what I call "learning the scales."

After years of music lessons, I finally learned what makes a great performer. At some point the instrument becomes an extension of the musician. Watching a jazz pianist like Thelonious Monk made me realize that great musicians are not thinking about where to put their fingers—they may not be "thinking" in the way we know it at all. The music comes out of them as effortlessly as they breathe. (That was the end of my dreams of a career in music, but the beginning of my understanding of my career in photography.) The performer doesn't concentrate on the scales or the routine progressions of notes, but what fits between the scales.

This is our goal in learning how to process files in a methodical way. We want the process to be as effortless as possible, without constantly thinking, "What do we do next?" When we know the scales—the routine steps in the digital imaging process—we are free to look at the unique things that make a photograph special, a brilliant image.

This part of the path, and the pieces of the process, show you twists and turns but also the most important features of control and versatility.

JPEGs in the Smart Object Workflow

Even if you have completely converted to the world of RAW shooting, you will inevitably run into some JPEGs you must work with. It may be tempting to go back to the old ways—either straight adjustments or adjustment layers. Well, stop right there; before you do anything, check out these five small steps.

1. Go to Photoshop>Preferences>File Handling (image A).

2. Select "Camera RAW Preferences" (image B).

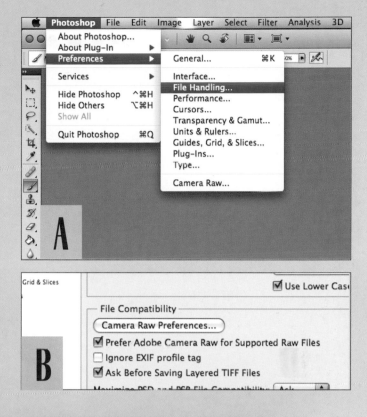

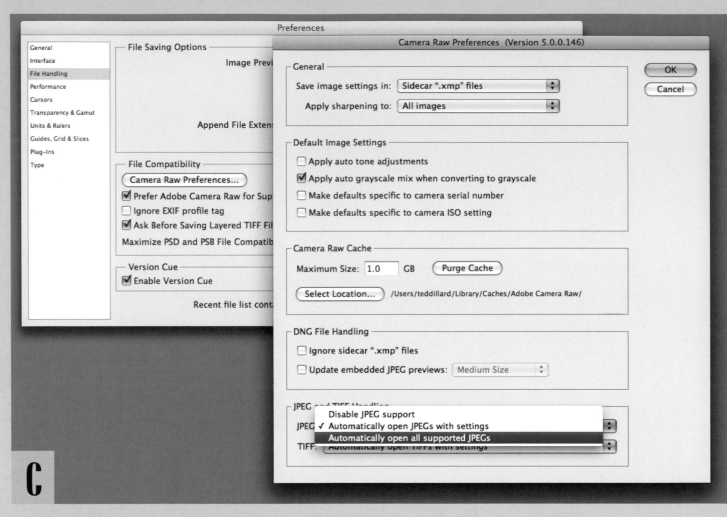

3. Select "Automatically Open All Supported
 JPEGs" (image C).

4. Close Preferences.

5. Open a JPEG.

Ta-da! Now, when you open a JPEG, it opens in Camera RAW (image D). All the usual rules apply. I select "Open Object" and there is my happy Smart Object layer (image E).

Note, however, that you are still working with a JPEG—not nearly as magical as working on a RAW file—and the JPEG is subject to all the usual issues associated with destructive editing in Photoshop. Anything you do, whether through the normal adjustment process or through Camera RAW, is a destructive edit. The difference is you are working in Camera RAW to apply adjustments rather than the Photoshop workspace.

I had a long chat with one of the guys at Adobe about this to try and discover what this meant and why they did it. He explained that they

wanted to give users an option for working with JPEGs if they prefer the handles (or controls) of Camera RAW. The advantage to working with JPEGs in Camera RAW is it standardizes the Smart Object process. Not only does everything work just as if it was a RAW file, but I can go back and readjust the JPEG as if it was an adjustment layer, since it's a Smart Object.

Want to work with TIFFs, too? Go back to Preferences and make it so! (Preferences>File Handling>Camera RAW Preferences>Automatically Open All Supported TIFFs.)

aliasing: Strictly (but simplistically) speaking, aliasing is the result of pixels in an image that do not line up properly. This can result in jagged edges where a smooth line is required, but most often refers to color aliasing, where the red, green and blue channels of a color image are visible on what should be a clean, neutral edge.

noise: The digital equivalent of grain in pictures, noise appears as specks of color in a digital file, most commonly in broad areas of shadows. It occurs most frequently when high ISOs are used.

chromatic aberration: Visible as color fringing around high contrast edges. It is caused when the glass in a lens focuses different wavelengths of light onto the same plane, but they are out of sync and don't line up. This is most common with wide-angle lenses.

The (Super Secret Smart) Aliasing/Noise Fix

I'm throwing this out as a simple example of how you can use some of the blending methods of layers with the Smart Object workflow. Most of the time this is the only place I'll really get into these features, but if you have a need for these modes, they are as powerful in dealing with Smart Objects as they are in a conventional process.

This is a nice way to deal with aliasing (the red-green-blue fringing we used to see in the early days of digital capture), noise (which we still see, especially at the higher ISOs), and chromatic aberration (which we see in low-quality lenses, especially wide-angle lenses).

All of these phenomena do much the same thing: They produce a pronounced red-green-blue effect where you shouldn't have one. Aliasing shows up on small areas of bright contrast—like blonde and white hair in a portrait—and looks like red, green, and blue patterns along the edge of the highlight. Noise shows up as a grainy effect, usually in shadow areas, and chromatic aberration is fringing at sharp edges and is usually more pronounced towards the edge of the frame.

You can fix these issues by creating a new layer and blending that layer with the one below it, using the "Color" blending mode. Here's how that works.

Here's a crop of an image with a subtle red-green-blue effect in the shadows (image A). This particular example is from an extremely high ISO setting—an attempt to pull a lot of detail out of the dark tones. The first step is to make a new Smart Object layer. On that layer I make a Gaussian Blur Smart Filter (image B); I run it up pretty high to make that top image really soft (image C).

Pull down the Blending Mode menu and select "Color" at the bottom (image D). Here's what you get (image E). To compare, here's what it looks like with the new layer turned off (image F).

Notice that the very subtle red-green-blue effect is now reading as a more neutral brown tone (although still kind of grainy). Also note that the bright orange fringe on the left side is gone. That is exactly what this method is meant to do: draw colors down to neutral. If you want to control which areas get hit with this "draw-down" and which don't, then you just have to go back to our old buddy, the mask.

Getting Organized: Layer Groups

Stealing a chapter from the folks using InDesign and Illustrator, let's look at Layer Groups—an indispensible tool for keeping all your stuff organized. Layer Groups are folders used to keep a set of layers together and control them as if they were one layer. Let's dive right into an example.

Make a mask on the main part of your Smart Object in the usual way, and there you have it. The tones in the dark areas are nicely neutralized, yet your nice color fringe still has its intensity (image G).

This process can be used anywhere you want to tone the color intensity down, but it's most useful when you're wrestling with camera and sensor effects that diminish image quality.

Here is my standard set of layers; we've seen it before (image A). The "Group" button is at the

bottom, near the middle, of the Layers Palette (image B). I could push that button to make a new

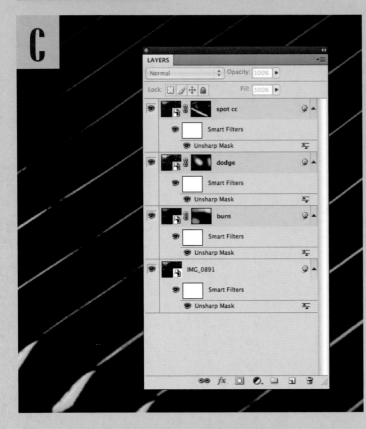

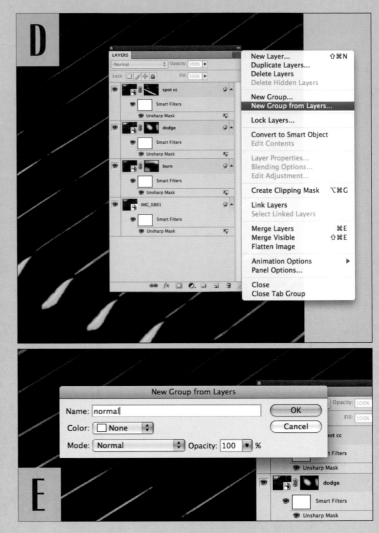

group, but then I'll have to click and drag the layers into the group. An easier way is to select the layers I want to group (image C), and go to the upper right Palette Options button. I get the menu and select "New Group from Layers" (image D). I then get a dialog box that asks me for a name and a "Mode." "Mode" refers to a Blending mode, see page 208, and for some reason it defaults to "Pass Through." I'd prefer it be "Normal," so I change that here, name the group "normal," (meaning my normal set of adjust-

ments), and hit OK (image E). I get a nice little folder called "normal" with my set of corrections inside (image F).

Suppose I want to do a second version of edits for another purpose. I do this when I have an image that I've made a fine print from, and I need to prep that file for press work, like a magazine or book. I make another set of adjustments and call this set "version 2." I select them, go to my Options, pull down "New Group from

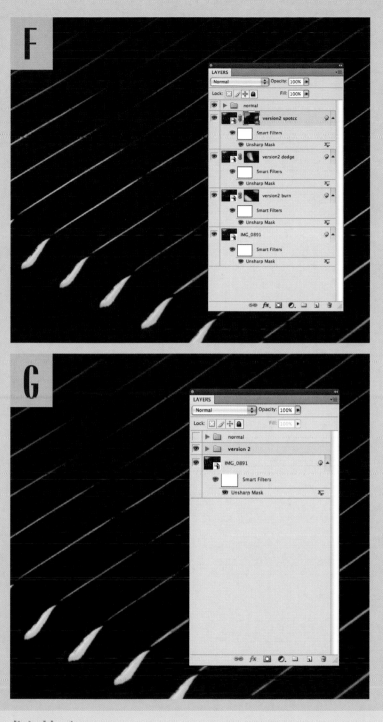

Layers" and label it "version 2." Take a look; notice that my "normal" group is now off, so I can work with my version 2 layer group (**image G**).

NOTE: To tell you the truth, the name "version 2" isn't too useful, and is not great **digital hygiene**. It doesn't tell me anything specific about that group of layers; I may know what it is now, but in a month I'm not going to remember. For that matter, the way my poor old brain works, I'm not going to remember next week. The best solution is to name it something a little more descriptive, like "offset," "prepress," or "magazine."

This is a cool trick for anyone using a lot of layers, whether they are Smart Objects or not. There is one caution with Smart Objects, though. As you remember, if you just copy a Smart Object it will actually link to the original. If you change one, it will change the copy too. This is because it's referring back to that "object," that location, and it's not making a new "object." It actually is copying the link back to the location in the file (which we discussed on page 121-122). The same is true for a group of Smart Objects. If you copy the group, the Smart Objects inside the group are just getting copied. If you mess with one Smart Object in one group, it will mess with the "linked" Smart Object, too. You just have to go in and make new Smart Objects the way we did before: Layer>Smart Objects>New Smart Object via Copy, and group them later, once they're built.

digital hygiene: A term I coined to help photographers understand that working in a digital darkroom is not much different that working in a old-school darkroom: A place for everything, and everything in it's place. If you organize and manage your files, as well as your habits and processes, then your workflow will be smooth and efficient. If you are disorganized and impulsive, you're going to waste a lot of time searching for files, looking for methods, and maybe get some pretty unpredictable results. Digital hygiene is the same as personal hygiene—take care of things now, and they won't sneak up on you later.

Blending Modes

The Blending mode is something we use pretty much not at all, but this is an ever-so-brief explanation and list of blending modes and what they do.

The blending mode tells Photoshop how to blend one layer's pixels with the pixels below that layer. Different blending modes give you different effects.

"Pass Through," the default Blending Mode for layer groups, applies anything you do inside that group—like adjustment layers—to all the other layers and groups. For our purposes of making versions, that's not a great strategy. "Normal" keeps our adjustments and effects restricted to that group alone.

See the Appendix for a complete list of Blending Modes and what they do.

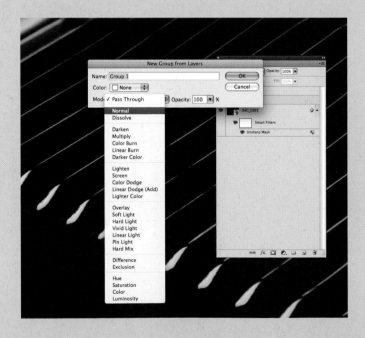

H ere's a quick rundown on a few common cropping scenarios, and how to backtrack out of them if necessary.

The first and probably most common situation you might encounter is that you're working away on a file, you have a ton of layers, and decide to crop the image. The easiest way to crop here is with the Photoshop Crop tool (*image A*). Simple enough. I apply the crop and my canvas size is reduced to my crop size.

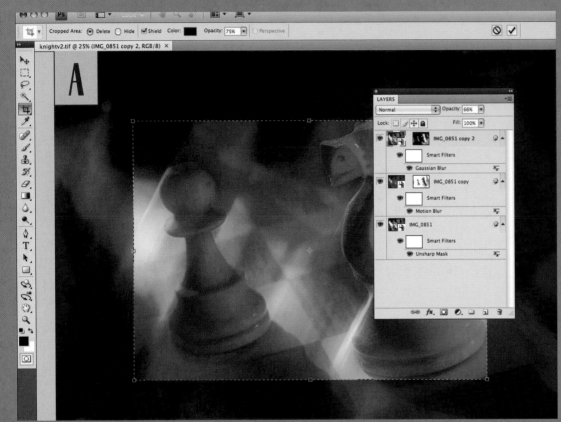

The way you backtrack from this crop is also simple: Go to Image>Reveal All (*image B*). Because the canvas was first set up with the whole object size and the Smart Objects are uncropped, you get the full image restored.

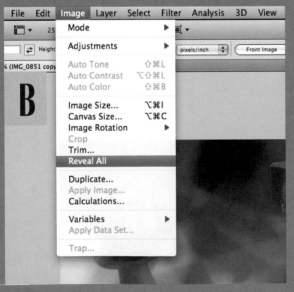

The next most typical scenario is that you open an Object without any crop, and before you start working you decide to crop it. If this is the only layer, then just go into the Camera RAW window, select the crop tool, and hit the <*esc*> button, undoing the crop (*image D*). Since your canvas is at full size because your first move was without a crop, you're all set. If you have multiple layers, you do that with each layer.

One last scenario is a bit more complicated, but happens occasionally. If you open a file and apply the crop right away, you build the canvas to that cropped size (*image E*). To backtrack on this one, first go back and void the crop. Open Camera RAW, select the crop tool, and hit <*esc*>. This re-renders the file at full size. Simply make the Image>Reveal All move again and it rebuilds the canvas out to the full size.

Using the crop tool is really the only practical way to crop an image once you've made a bunch of layers. If you try to crop one of the Smart Object layers with the Crop tool in Camera RAW as I have here (*image C*), you get only one cropped layer, it is re-centered in the canvas, and that moves it out of registration (that is, it doesn't line up with the other layers anymore).

CHAPTER 10:

SMART FILTER LAYERS

Copying Smart Filters from Layer to Layer

Copying Smart Filters is a useful technique for when we want to apply a filter with the same settings to several layers. Most often this happens when we are masking most of a layer and combining a few layers that have smaller active parts.

The good news is that we can copy existing Smart Filters much in the same way we copy other things in layers, but just as with other little features of Smart Objects, there are a few new twists to watch out for. Here's a step-by-step example.

I open a file and for the sake of simplicity I'm just building a "burn" layer. It's duplicated from the source layer, so it duplicates the basic Smart Filter, too. To keep things straight, I'm going to turn that Smart Filter layer off by clicking the eye next to the "Smart Filter" mask (image A). I'm going to burn down the eyelashes and the iris a bit here; I've made the adjustment and masked it for just those parts (image B). Now I want to get it ready to print, so I size it and make my

Unsharp Masking adjustments (image C). I'm making those adjustments on my source layer.

Now I have a problem. The areas I burned are covering up my source layer. The Unsharp Mask filter I applied is not visible because of the burn layer above it. The burn layer isn't going to get sharpened by the settings I just made, so I have two choices: I can go in to the Smart Filter on the burn layer and make the same adjustments, or I can simply copy the filter from the source layer and drop it in the burn layer.

I'm choosing the second option; here's how I do it.

I start with the burn layer and turn off the Unsharp Mask Smart Filter (image D). Back in the source layer, I click on the Unsharp Mask Smart Filter. Hold down "Option," click on the filter, and drag it to the burn layer, and drop it directly on the Unsharp Mask section of the Smart Filter.

There it is. I've added a copied Smart Filter layer from the source layer (image E). Note that there are two "Unsharp Mask" layers. You can deactivate the lower one—the original—if you'd like,

or you can delete it to keep the layer palette organized.

NOTE: When you try this technique, make sure that the thing you've turned off (in your target layer) is the filter itself, NOT the thing that says "Smart Filters." Look again at image D. The eye is active next to the "Smart Filters" but not next to the Unsharp Mask. This will help keep things straight, because it adds a new filter that has the eye, and shows the old one that is turned off. (If you turn off the "eye" next to the Smart Filters, it will still add the filter but activate all the layers—just a bit confusing.)

The only thing left to do is to go back and check your sharpening levels. Remember the Rosenholtz-Sanchez effect—you've applied the same filter twice, on two layers, and if you've applied two layers with masks the effect will be compounded. You can check it quickly by toggling the new filter on and off to see if the effect is objectionable, or you can re-open that filter and give it a poke.

Multiple Smart Filters

Here's an interesting thing. I'm starting with a source layer and adding Unsharp Masking with a mask to select only the eyelashes of my model (image A). If I then add another filter, it piles on top of the filter but under the mask. This creates a double-filter effect with no way to selectively

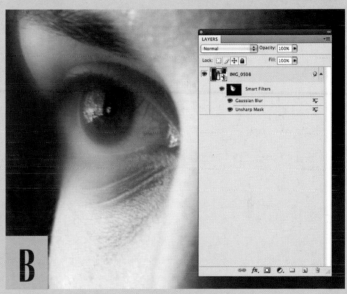

apply the different filters (image B). They affect the active part of the layer mask.

If you have a few filters you like to use and they work well together, that's fine. But if you don't want both filters to apply to the active area of one layer's mask, then make the blur filter, copy the mask, and invert it.

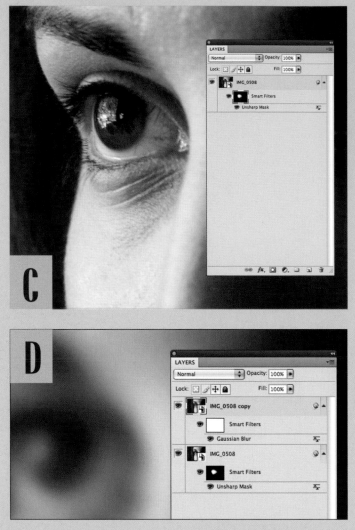

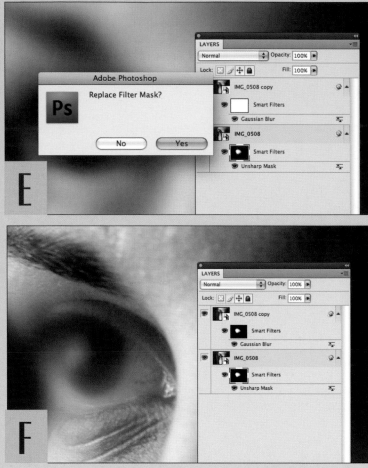

Here's my first Layer with the Unsharp Mask filter applied to only the eyes (image C). My next step is to add another layer and create a Gaussian Blur filter (image D).

If you click on the source layer mask, hold down <Option>, and drag it to the top layer's Smart Filter mask, you can copy it to the new filter layer (image E and F).

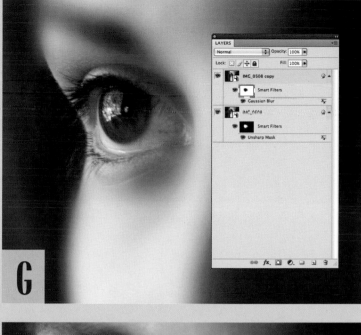

<Command+i> inverts the mask selection, and you get the blur filter effect on everything except the eye, where you have Unsharp Masking (image G). I can even go in and turn the opacity of my blur filter back to soften the effect a bit when I work this way (image H).

Smart Filter Masks

When you make a Smart Filter on a Smart Object layer, a mask is automatically generated (image A). The white rectangle labeled "Smart Filters," between the Smart Object on top, and the filter on the bottom, is your mask. This is separate from the filter, and will, for the most part, behave like a regular layer mask that we know and love with a few notable exceptions.

The first little surprise is that you can only use one mask for each Smart Object Filter set. I can add more filters, but they're just going to sit under that top mask. Here's what that looks like (image B), and I've applied two filters that don't play well together—a bad idea. As we've discussed, this means you're stacking filters on top of each other, and you really have no way of selecting which areas each filter applies to.

I can control the masked areas of the filter just like I do with a regular mask (image C), either by

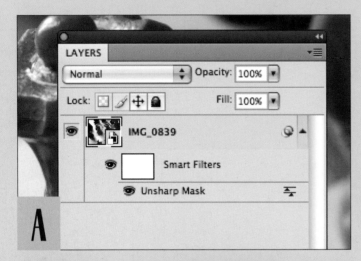

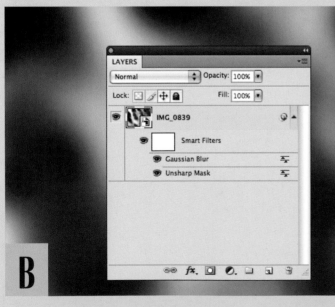

painting on it or even by making a selection and making a mask (image D). The trick here is to make the selection before you make the filter. In image E, I've made a selection from Select>Color Range (see page 170). Next I make a Smart Filter for Gaussian Blur (image F).

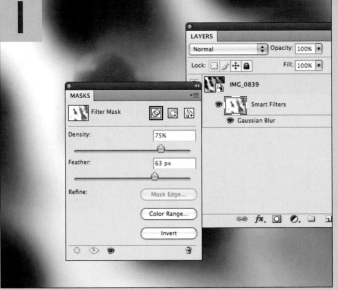

Here is my happy mask (image G). I can make the usual moves here, such as <Command+i> to invert the mask (image H), as well as access the CS4 Mask Panel to make some nice, controlled refinements of my mask (image I).

Another interesting difference is that when you mask the Smart Filter, you don't get the Rosenholtz-Sanchez Effect; you can duplicate the Smart Object to your heart's content and you don't get a compounding of the filter. If I have the mask on the layer, and not the Smart Filter, then I've got to be careful. I'll get what looks like a compounded filter effect, but is really a compounded mask. (See page 190 for an explanation of compounding masks and the Rosenholtz-Sanchez Effect.)

ONE FINAL NOTE: You can move and copy Smart Filter masks from layer to layer, just as you can with regular masks, by dragging them to the layer you want to move them to, or by Option-dragging them to make a copy rather than a move. This second option has one restriction: You can only copy a Filter Mask to another Filter, and a Layer Mask to another Layer. The "Filter Effects Mask" and the "Layer Mask" are two different animals, and can't be interchanged.

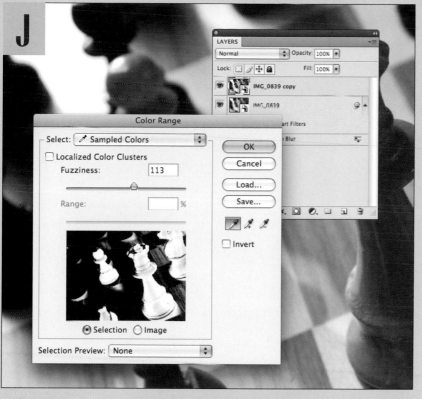

This gives you an interesting workaround option, though. If you've made a Smart Filter and decided afterwards you want to mask it using a selection, just make a new Smart Object layer, make your selection (image J), and make any filter at all (image K).

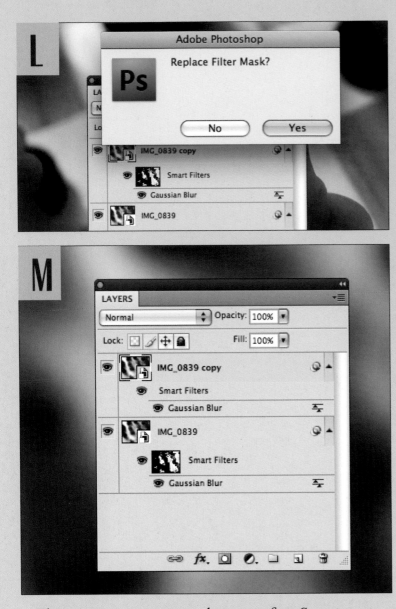

Then, just move your mask to your first Smart Filter. You'll get this warning (image L); it moves that mask to the first filter (image M), and you can then delete the second "working" Smart Object Layer you made (image N).

If you have any doubts about the future of Smart Objects, just take a look at the Photoshop plug-in world. Nik Software, for example, now supports Smart Objects as Smart Filters in all of their plug-in software.

A plug-in, for those of you wondering, is a handy little piece of software that operates inside of Photoshop. It's a great solution to a software designer's challenges; it allows you to take advantage of the overall Photoshop architecture to support some of the bigger operations of any software package, yet create a sweet little independent application. Scanners and filters are the typical places for plug-ins, and even Camera RAW started as a plug-in back in the Photoshop 7 days.

Here's one example of a nice plug-in: Nik's recent addition to it's product line—Nik Silver Efex Pro. You install the software, and it looks for any Photoshop versions installed, and dumps itself into the plug-ins folder. Once that's done, you can access it either in the filter pull-down (Filters>Nik Software>Silver Efex Pro; image A) or with the handy panel it allows you to set up in your workspace (image B). Once it's there, you just use it like any other filter. Here's what the main control screen looks like: (image C).

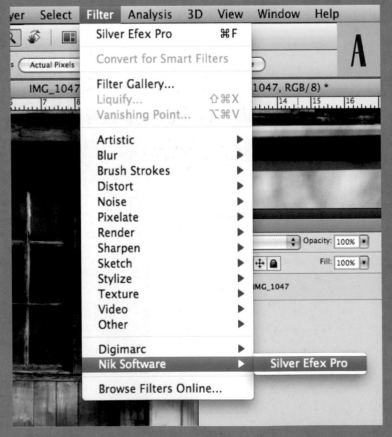

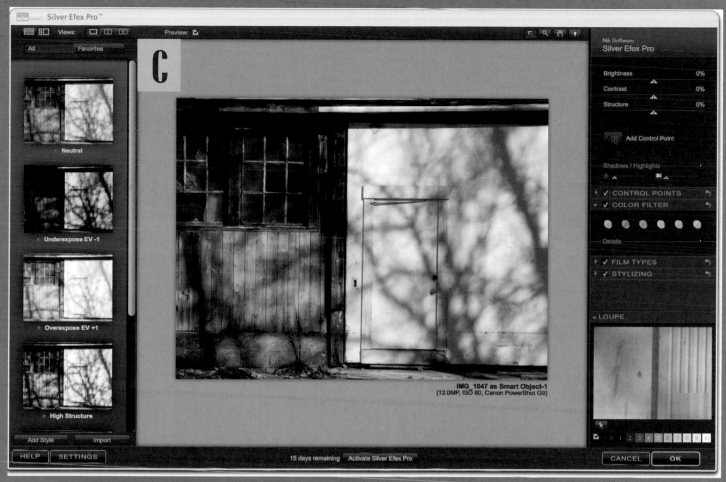

One of the things I really like about this software is it's not far from the appearance and handling of the Camera RAW panel. Rather than try to reinvent the wheel, Nik has worked in their own controls harmoniously with Adobe controls, which is very helpful and easy to adjust to when switching between programs, and especially in a plug-in.

Once I hit OK and apply the processing of the filter, I get the same Smart Filter appearance I'm used to, complete with masks (*image D*).

This is huge, pointing the way to broader software development outside of just Adobe. Nik, for one, offers some great packages for alternative processing—noise reduction, color controls, sharpening—which are even more useful and powerful in the Smart Object workflow.

CHAPTER 11:

AN INTRODUCTION TO ACTIONS

Working in the Smart Objects and masking workflow requires basic file prepping for almost every image. I try to standardize my processes, so I essentially repeat the same set of commands every time I start working on a file. Keyboard shortcuts are great shorthand for individual commands (like everyone's favorite, "Undo," <Command+z>), but when you have a series of tasks that are repetitive, nothing beats Actions.

Actions are little **scripts**—a sequence of commands that you're directing Photoshop to perform—but they're set up so you don't have to be a programmer to make this script. You decide what you want to do, start up a new Action, select "Record," input the sequence of commands, and stop recording when you're finished. You've created an Action.

scripts: Like Actions in Photoshop, scripts allow you to pre-program a series of steps (or commands) that make repetitive tasks faster and easier. For Adobe programs, scripts are usually written in Javascript, a common programming language.

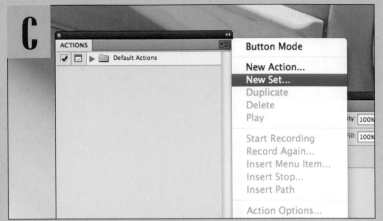

Start by finding the Actions palette: Window>Actions (image A). Image B shows the palette with the default Actions set (cleverly named "Default Actions"). There are a lot of Action sets available there, but we are making our own set. Go into the little button at the top right of the palette—it looks like three lines with a tiny "down" arrow—and select "New Set" (image C).

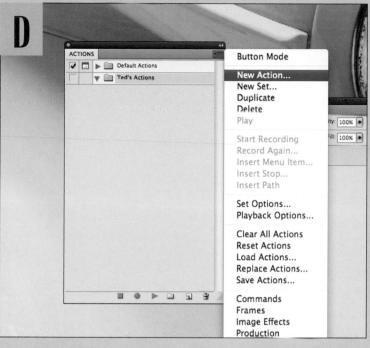

NOTE: Make sure you start out with the "Default Actions" set selected so that the new set is created as a selection outside of the Default set.

I'm naming this new set "Ted's Actions." Once I name the set, I go back up to my little three-line button and select "New Action" (image D). I get this little window (image E). I name the Action (Prep Smart Objects), make sure to select "Ted's Actions" in the set drop-down menu, and I'm ready to start recording. You guessed it: Hit "Record."

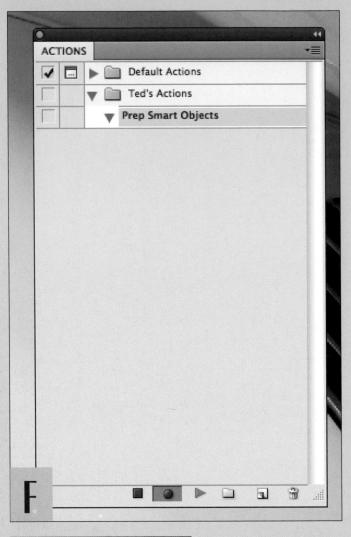

F

G

Once you start recording, every single **command** you make is recorded. It will be listed in the Action palette where all the details of the command are shown. Look at the bottom of the palette: there is a round red dot that acts as the "record" button (**image F**), a "stop" button, and a "play" button, just like a tape deck (**image G**). Anyone remember tape decks?

command: A command is a processing step you are telling the software to take. It may be as simple a series as: Open, Save As, and Close. These steps are saved as commands that are executed when an action or script is run.

Here's the important part: You must have the command sequence figured out before you hit record. When you plan this out, keep it neat and efficient. If you have a complex set of tasks, give some thought to making a few separate actions, rather than one big cumbersome one. You can go and edit the action by deleting and re-recording, but frankly it's easier to just start over and make a new one. Once you have what you think is right, then test it on an expendable file, because I guarantee you you're going to make some mistakes. If you make mistakes on your only originals, well - you know the words to that song. (Of course, you shouldn't ever be doing any work on your only copies of anything anyway.)

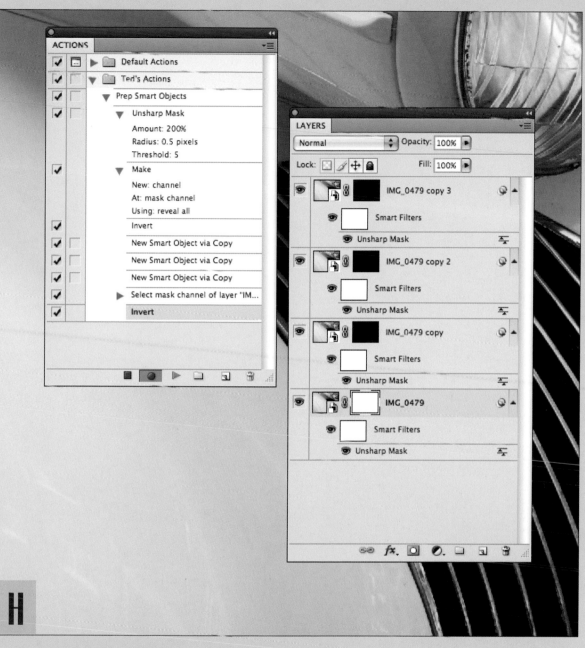

This is the result of my standard series of file preparation steps (image H). I've already hit the "Stop" button, and here is my file all ready for me to start work on. If I have any questions about what the Action did, I can check the individual steps listed in the Action palette.

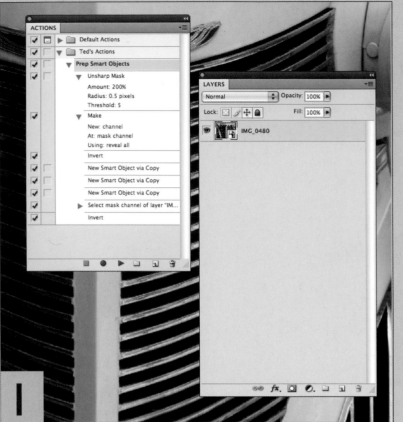

Now, for the sample test: I open a new file (**image I**) and make sure to select the title line, "Prep Smart Objects," (the Action is going to run from whatever is selected, using that as the starting point), and I hit the "Play" button (**image J**). My result is exactly what I wanted, performed automatically for me, and completed in about a quarter of the time it would have taken me to do it myself (**image K**).

Actions are the basic starting point in an array of automation options. Once you can make an Action you can use it in Batch, Image Processor, and other areas, so not only is it worth learning for Smart Objects, it's a rabbit hole I'd very strongly suggest you tear into with a book like *Real World Photoshop* or something like that. This, however, can get you going with Smart Objects and Actions pretty quickly and save you a bunch of time preparing your processing.

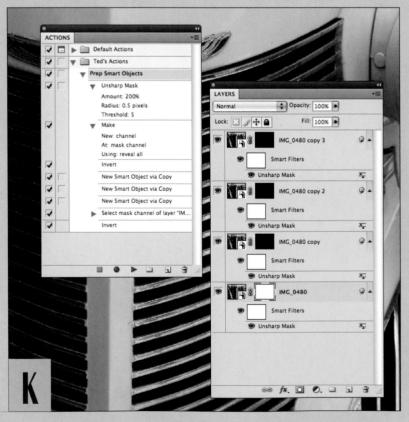

Creating Keyboard Shortcuts

Making a copy of a Smart Object layer is kind of a pain—the process consists of going to Layers>Smart Objects>New Smart Object via Copy (image A). If you duplicate the Smart Object using the usual "Duplicate Layer," or by dragging it to the little icon in the Layers palette, it makes a Smart Object that is linked to the one you copied it from; everything you do to one will be done to the other.

This is an example where making your own keyboard shortcut can save you a raft of time.

Go to Edit>Keyboard Shortcuts (image B). Scroll down to whatever command you want to create or modify a shortcut for, and select it.

Keyboard Shortcuts and Menus

Keyboard Shortcuts | Menus

OK

Cancel

Set: Photoshop Defaults

Shortcuts For: Application Menus

Application Menu Command	Shortcut
Delete	
Enable/Disable Vector Mask	
Link/Unlink Vector Mask	
Create/Release Clipping Mask	Opt+⌘+G
Smart Objects>	
Convert to Smart Object	
New Smart Object via Copy	Shift+⌘+C
Edit Contents	
Export Contents...	

Accept

Undo

Use Default

Add Shortcut

Delete Shortcut

Summarize...

⚠ Shift+⌘+C is already in use and will be removed from Edit > Copy Merged if accepted.

Accept and Go To Conflict | Undo Changes

C

You get a window where you put in your choice (image C). If it conflicts with something that is already set up, as mine does, you'll get a notice. Seeing as I never use the "Copy Merged" keyboard shortcut, I click "OK" and accept the conflict.

Now when I hit <Command+Shift+C>, I have a new Smart Object layer.

*W*hat's that you say? Smart Objects are all well and good, but you really like your LightRoom2 workflow? That's fine, because with the release of LightRoom V.2 you get an easy Smart Object crossover between Photoshop and the world of LightRoom (*image A*).

Suppose you've made a few adjustments to an image in LightRoom2, but now you want to build a couple of Smart Object layers in Photoshop. No problem. Go to Photo>Edit in>Open as Smart Object in Photoshop (*image B*). This will apply the adjustments you've made, bypass Camera RAW, and

C

open your image up in Photoshop. I've made a simple Smart Object layer and a blue tinted blur filter (image C), and, once I "Save" or "Save As," LightRoom2 will add the new image into the Library (image D).

This is what the software guys like to call a "round-trip." You start in LightRoom, move it into Photoshop, and come right back to LightRoom to keep track of your new image file.

Of course, now that you're back in LightRoom you can make all the usual adjustments, but you have to keep in mind you're applying them to the TIFF you've saved, not the RAW file or the Smart Object layers. It's just like making an adjustment layer on top of a few Smart Objects in Photoshop, and is just as destructive to the edited TIFF.

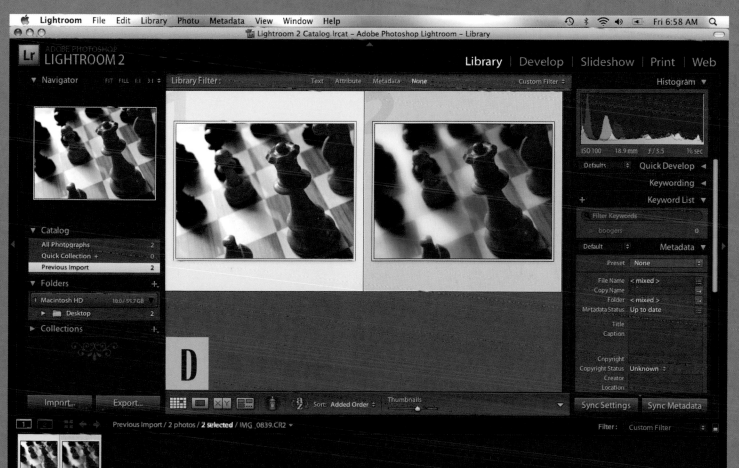

D

CHAPTER 12:

VARIATIONS AND ARCHIVING

Down the Rabbit Hole of HDR Processing

HDR, or High Dynamic Range, is a processing method that combines several exposures of different exposure ranges to create one file with an enormous dynamic range—much larger than what one can capture in a single exposure.

I saw this with Leaf software very early on; you could take the RAW files in Leaf Capture and merge them into one HDR file. This was particularly useful when shooting computer or video displays, or interiors with windows.

The problem was (and continues to be, as far as I have seen), the lack of control in selecting what highlights are included and where, as well as the lack of a re-editing strategy. You can't go back and change anything after you've made the HDR image. Later on, Imacon came along and allowed you to select several exposures, process them to one file, and work on them with layers in Photoshop—a much more practical approach from my perspective. Using masks and layers, I

could select what and how much of an area or value I wanted to include in a shot.

Then came the Smart Objects. No surprise there, huh? If I take several exposures and build them into my layers and mask them, I have all the dynamic range I can stand, nicely contained in my "non-destructive editing" workflow. The HDR processors I have seen make one huge ultra-high bit-depth file that you can use as a source for all your edits, but the Smart Object workflow lets me use the same workflow I'm using for everything else—Smart Objects, Layers, Masks—to build in every bit of detail I want, in just the way I want.

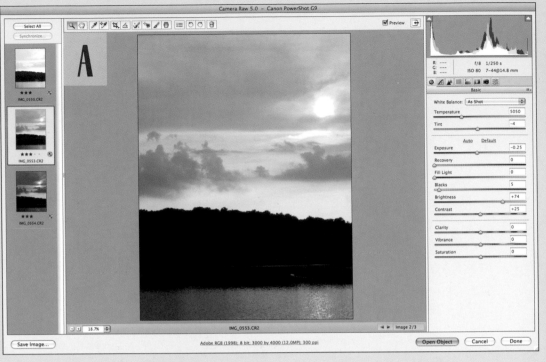

Smart Objects: Getting to Dynamic Range

Using the Smart Objects workflow, I start with three exposures, each one about 2 stops apart. These shots were taken on my bike ride home, without a tripod, so I'm hand-holding the camera and trying to line the shots up as best as I can. While I'm making the exposures, I think of what my challenges are and what I need to put this thing together as I'm visualizing it. The sun is going to basically blow out to pure white, but there's a lot of detail in the clouds around it that I can retain if I make an "underexposed" shot. The shadows—mainly the trees on the shore—are going to go to pure black if I expose for the sun. They are pretty dark, even for my baseline exposure, so I use my exposure value (EV) setting to overexpose the image and capture some detail in the darkest shadow tones. I've got three basic sets of information covering about 25 stops, or EV values, of dynamic range.

I select all three in Bridge and open them. Once they are open in Camera RAW, I adjust each one to maximize the detail that each one can give me (image A).

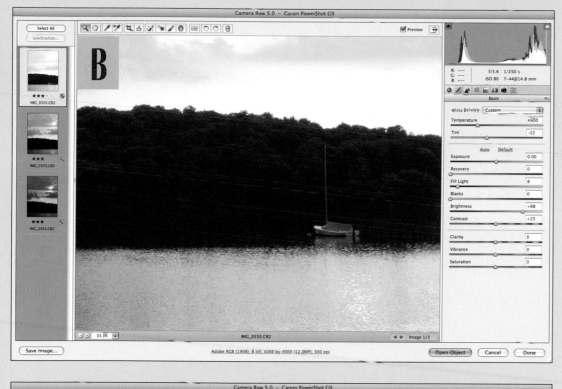

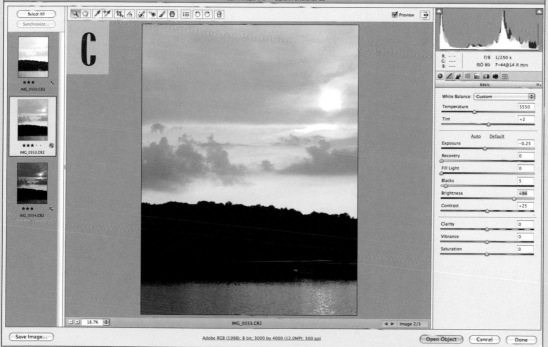

The first image is my exposure for the shadows, the green shoreline. I make the most of this, opening up the blacks, turning up the brightness, and shifting the color towards green (image B). The second image is my normal exposure, and I work that to make it look as nice as possible, as well as enhance the magentas and oranges a bit (image C). The last image is the exposure for the highlights—notably the sun and surrounding clouds. The sun itself is blasted out entirely, and the transition between the sun and the brightest clouds is a distinct line, so I need to handle that gently to avoid any ugly banding.

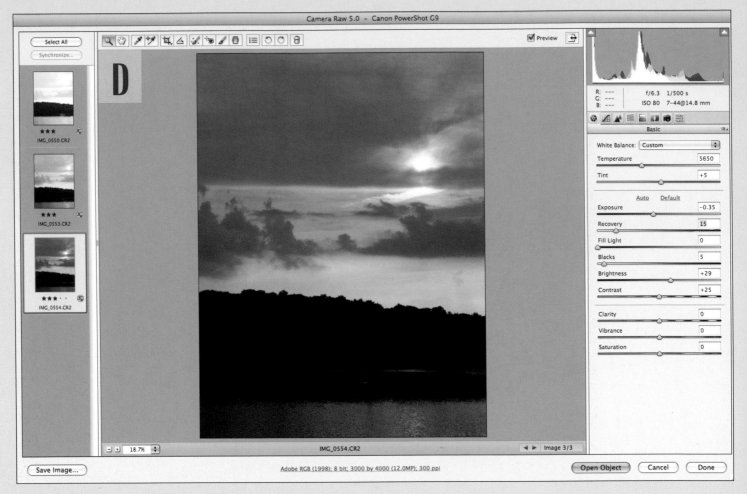

I do that with the Exposure slider, which controls the highlight clip, and the "Recovery" slider, which smoothes the transition (image D).

When I'm happy with the image adjustments I've made in Camera RAW, I "Select All" and open them in the Photoshop workspace. Once they are open, I start with the middle exposure and name it the "base image" in my Layers palette. Using the Move tool, I go to the dark exposure and Move that onto the base image. I do the same for the bright image and name them accordingly (image E).

Note that I have not lined the images up—I've just dropped them on top of one another in an effort to set up the layers. To line them up, here's the process. In each layer, one at a time, you turn off the other layer and turn the Opacity of the layer you're working on down to about 50%. Here, you see my "sun burn" layer down to 52% (image F). (50% is just a starting point.) I use my Move tool again to slide this around to line up the sun (image G). I go to the other layer, the tree dodge layer, and do the same thing—sun burn is off,

tree dodge is at 50% or so, and I slide that one around until it fits (**image H**).

Look at this carefully for a minute (**image I**). The sailboat is aligned perfectly but the trees on the skyline are not at all. This is fine, and that is because I am only using the bits and pieces of these burn and dodge layers to create the final image. If the boat doesn't line up right, it is going to look really bad. On the other hand, the mushy trees deep in shadow will not be as discernibly out of register. If it's a problem, then I have to make another layer (Layer>Smart Object>New Smart Object via Copy), and move that around separately. You'll see more of what I'm talking about once we mask this example.

Now I can mask the layers to burn and dodge them, starting off with all the exposure values from my 6 **EV range**. I have the control of layers and masks with the ability to go back and edit the RAW source file because of the Smart Object. I can fine-tune the value, the color, the sharpening, the opacity, and blending of the layer, too.

EV Range: Exposure Value Range describes the amount of difference between your brightest and darkest exposures in a series of a subject.

J

K

Here's what the Layers look like once I've done my masking (image J), a before shot (image K), and an after shot (image L) that shows all the effects I adjusted for: opening up the trees and the boat, bringing green in the trees and orange in the clouds, and holding the detail in the highlights around the sun.

Working with a huge dynamic range can be kind of dangerous. Many of the automatic programs take all this information and crush it into a normal dynamic range. The key here is visualization and knowing how to stay true to the intensity of your original subject. My aim is not to collect every single bit of highlight and shadow detail and represent them in one file; my aim is to play them off each other to create the vibrancy and luminosity of that sky and the water, just as I saw it in life and envisioned it in my mind's eye.

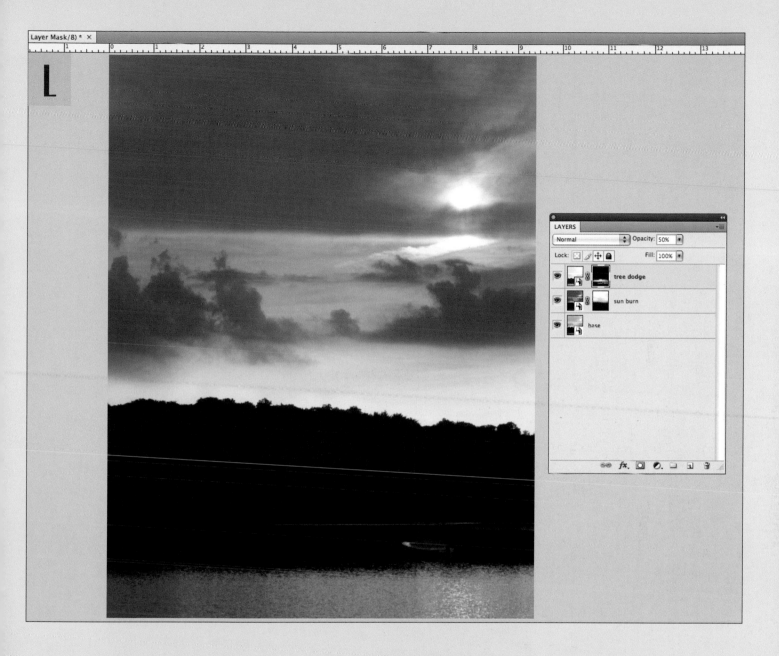

GEEK ZONE: ALTERNATE PROCESSING, SMART OBJECTS AND THE OLD "PIN REGISTER" TRICK

Occasionally you may want to use other processing software to take advantage of a specific feature. For example, Nikon software tends to do a really nice job with the shadows, increasing sharpness, and decreasing noise; Canon DPP handles sharpening in a slightly different way from Camera RAW; and Iridient Digital's RAW Developer gives you some interesting controls that you don't see elsewhere. Although these programs don't currently support Smart Objects, you can still take advantage of their features and build them into your layers.

The workflow is the same when you are using other software. Process the file, drop it in as a layer, and mask it for what you want. You just have to make sure you line it up right, and for that we use the "pin-register" trick. Holding the <Shift> key while you move one image to another image will line it up perfectly pixel-for-pixel.

Here's how it works (image A). I have two images, one processed as my usual Smart Object, and another processed using Canon's DPP software, for the neat sharpening it does. The DPP version (labeled as such), is sitting on top. With the Move tool selected, I move it to the Smart Object version, holding the <Shift> key.

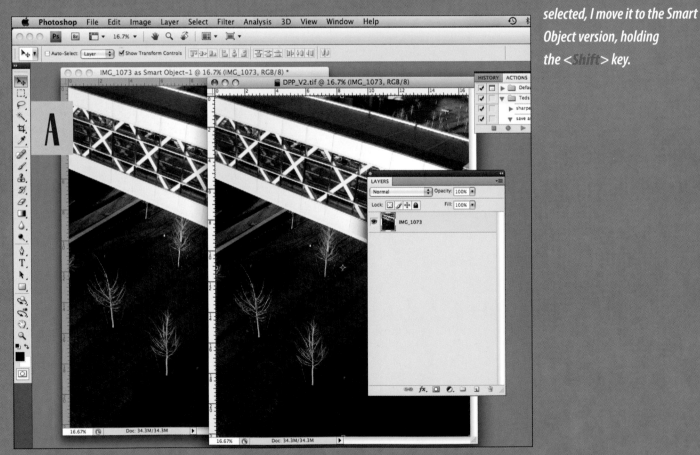

Here's what it will look like (*image B*). I now have an image layer on top of my Smart Object layer.

I mask it and apply the parts I like, in this case the branches of the trees. Naturally I've labeled the layer, and here's what the file looks like now (*image C*).

Hopefully, as the process progresses, there will be a more elegant solution. We're limited here by the fact that we can't go back and tweak the processing without creating an entirely new layer from the original software, but maybe soon we'll have an alternative processing Smart Object workflow much like we now have plug-in support for Smart Filters.

Archival Challenges with the Smart Object Process

The task of archiving images—that is, of preparing, saving, and storing images in a system that is safe, consistent, and easily accessible—is pretty daunting, and there are a number of issues.

When it became clear that digital photography was here to stay, and that one of the results was that even the most conservative photographer became overwhelmed in a rising tide of digital files, the photographic community began to express concerns about the fate of these images for future generations.

There were a few basic questions: "How could we keep track of this wave of digital files and save the images that are significant?" "How can we be sure, in this context of changing technology, that we can even read or translate image files in the future that we make today?" This last question brings up the issue of file standardization, storage media, and interfacing devices with systems—and that's only the beginning.

The file standardization issue applies strongly to RAW files, too. At this point every camera has it's own RAW file, and within a very short time we've been buried with this list of cameras supported by RAW processing programs like Adobe Camera RAW and Aperture. Who hasn't run out to buy the latest digital camera, only to find they have to wait for the Camera RAW update before they can read RAW files in Photoshop? This could work the other way, too.

Who's to say that Adobe won't drop support of a certain camera's file format, although this has not happened yet?

To fully understand this issue, look at it from a little beyond the perspective of a photographer. I'm primarily concerned with being able to open my files in five years or so; this means I need to have them on a media I can still read. For the record, up until a few years ago I still had gigabytes of files on 100MB zip disks. Not only are the zip drives hard to find today, but I'm sure some of those disks are now unreadable, just from old age. To make matters worse I

used those disks before understanding the need to make duplicates of everything—known as redundancy—so if one fails, you have the other. Live and learn.

I also have RAW files from a camera—the Megavision S3—that are no longer supported by today's software. Luckily, I ripped some TIFFs from those shoots, but the RAW files are pretty much out of reach.

Another issue bothers me. If I work my butt off to make a killer print, how can I save all that work? If, indeed, future generations are the least bit interested in my photography, I want them to see the image the way I interpreted it. So, I

want my cake (the untouched RAW file in an accessible form), and I want to eat it too (my processed files, also accessible).

The other side of this issue is the archivist's perspective, such as a curator or an historian. John Wolfe, the director of the Photography Department at the Museum of Fine Arts in Boston, once explained this to me. He deals with photographing artifacts in the museum's collections, and they are not only concerned with providing a responsible digital legacy from the photographic standpoint, but they also need that legacy to be an accurate representation of the original artifact. They archive both a final inkjet print as well as the adjusted TIFF, among other things. The theory is that the most reliable rendering of a subject's color and tones can only be interpreted by the person who is there—namely, the photographer. The photographer has the subject, the file, and the print all together in one place.

This opened my eyes a bit. My habit, based in my film experience, was to store my negative as safely as I could, along with my notes and the prints that I had. My theory was that my negatives were the "source" of my image, and the other stuff was less important. That's because I was thinking only in terms of my own needs. If I went back and re-printed an image, I was assuming I'd be able to make a better and different print in later years as my talents developed. I wasn't really consumed with printing it exactly as I had. Suddenly, I realized that if anyone was

pawing through my stuff in twenty years, they'd be as interested in the prints and the notes as they were the negatives.

Which brings me to the most interesting part of this discussion: In my opinion, the challenge we face as photographers is making images that are worth saving.

I read a post in an online forum of photojournalists discussing storing and archiving. The most interesting post said there is a deluge of digital images out there—important images that are worth preserving and images that aren't—and a vast majority of them will be lost. It is up to the photographer to create images worth saving, images that rise above this "tide" of data.

To go back to my Megavision example—the camera whose files I can't open—the honest truth is that I could open them if I wanted to. I would have to use an older computer that runs Mac OS9 and find a copy of the original software, but I could do it. I may be able to actually still contact the developers, and get a newer version, but I certainly, with a lot of effort, could read those files. The problem is that is almost isn't worth it.

You can be certain in this world of techno geeks that in twenty years there will be someone somewhere who has a Powermac G4 that's running OS9. My friend David O'Brien has one of the earliest television sets, one of those things that looks like an alien eye, sitting in his living room, humming and buzzing away. (I still can't get over the fact that you turn it on and

see "American Idol." I have this overwhelming expectation that I'll see "I Love Lucy" when I turn that knob.)

The key is, I've got to make photographs that are important enough to try to open with outdated technology, and the rising tide of images just raises the bar. Some see this as a threat; I prefer to see it as a challenge and something that will push photography to a new level of excellence.

So now the question is how do we make our images files accessible, and what has to happen in the Smart Object workflow to accomplish this?

Look at this (**image A**). I'll preface this by saying that I don't do this to every file, but I do work like this with the images I feel are my most important. You can see my source image, which we've seen I can rip out as my original RAW file (Layer>Smart Objects>Export Contents)

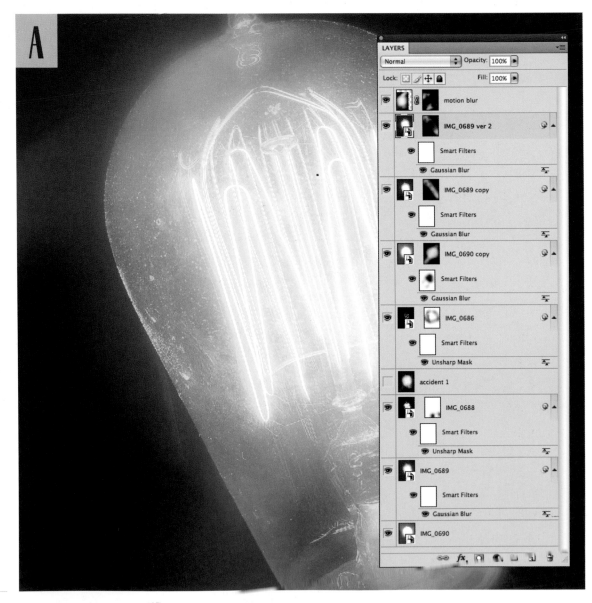

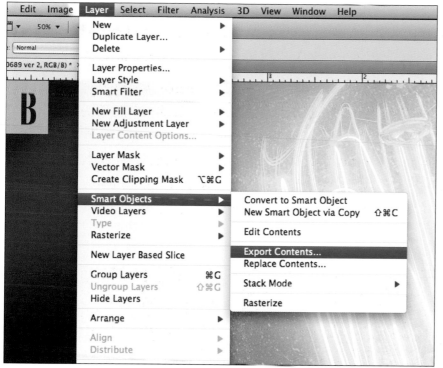

format (see the DNG GeekZone sidebar on page 258) builds the XMP files into their metadata, but so does the Smart Object layer. It doesn't matter whether it originates from a DNG RAW file or a manufacturer's file; as long as Camera RAW supports that format, the Smart Object will be able to work with it.

Finally, in the words of a buddy of mine who builds engines, if you want the horsepower, you gotta pay the money. Here's where you pay in the Smart Object process: Take a look at the size of this image file (image C). Yep, you're reading it right; 377.3 megabytes. This is also called "overhead."

Every time you add another Smart Object, you are essentially adding another RAW file. If your RAW file is 30MB, you're adding 30MB for each Smart Object. If I do this for every image I shoot, I'm going to be buried in data and storage, but I don't. I do this for only the images that I feel are my most important—images I used for exhibits, portfolios, books, anything that I want to keep for my own future work, but also, anything that I think I'd like to add to the archive. I'll do this to some image files on a limited scale, and some I'll do even less, but I'm making the decision with one eye on my needs today and one eye on the future.

(image B). Think of this as the negative; it gives me, or anyone else, access to the original unedited data. In addition to that I have all my darkroom notes in the layer groups for every iteration of the file. Each layer group has all the work I've done—every single thing—and is integrated into the TIFF that I save and archive. Future generations (if they care) see not only what I've done to the image; they can see it just as I last "touched" it.

Remember the XMP files? In a typical RAW workflow, the XMP file is the sidecar file that holds all my notes. The controversial DNG

*E*arly in 2005, Adobe introduced the digital negative RAW (DNG) file format in an effort to create a universal RAW file standard. Each camera manufacturer makes it's own particular RAW file, encoded in its own special way. The DNG file format is an attempt to establish an industry standard— a universal RAW file. Much of the information Adobe released at that time was speculation: Would other software developers support DNG? Would camera manufacturers adopt DNG? Would photographers use it? Is it a true, high fidelity conversion of the image?

I jumped on the DNG bandwagon immediately and then jumped off just as quickly. There were too many unanswered questions for me to commit to the DNG format. Now, after some time has passed, I think it is time to revisit DNG and evaluate it realistically. Where does it stand in a serious workflow? How does it hold up in terms of the file, and thus image, quality? How receptive is the photo industry is to using it? My first stop was to an Adobe developer, specifically some of the folks behind Adobe Camera RAW, Lightroom, and the DNG format.

My questions were pretty basic concerning the aspects of the DNG standard.

What does the DNG file contain?

My biggest concern is that the most and best information about what the sensor captured is saved in the file. In the conversion from my camera's RAW file it is important to know what gets saved and what gets tossed, and whether I will be able to process as high-quality of an image as I can from the original RAW file.

The DNG contains the digital latent image. The sensor data is the grayscale, mosaiced, raw pixel "dump"—this is what I've described as the digital latent image. It is the unprocessed pixel-by-pixel image information, and the only conversion it has undergone is from an analog signal to a digital value.

The DNG file contains the metadata. The metadata identifies the camera and the shooting parameters. Adobe Camera RAW uses this to determine the camera profile, specific information on what settings to use in mapping color, and reads shooting settings.

The DNG contains the preview JPEG. This was news to me. The camera makes a little JPEG that shows up on the camera's LCD playback and is processed according to the settings you made on the camera. This preview JPEG is embedded into every type of RAW file.

The DNG file contains "sidecar" information, or in the case of Adobe, the XMP file. This was more news to me. Whenever you process a RAW file, a small file is created to record all of your processing settings. When you open up the RAW file next time, Adobe Camera RAW reads this file to see how you want to develop your digital negative. This is the "sidecar file"—the XMP file. Other processing software makes their own sidecar files and calls them different things.

Here's a Nikon NEF file, DSC_1950.NEF. I've processed the file using Adobe Camera RAW, Bibble, and PhaseOne C1Pro. You can see here the original NEF file, the .bib file, and the .xmp

file from Bibble and Adobe. PhaseOne makes a .plist file and buries it in a folder called "Image Settings." One RAW file, three sidecar files. It's a mess.

Sidecar files present a big problem. First, if you separate the RAW file from the sidecar file, the RAW file is considered "unprocessed," reverts back to the default settings, and all the adjustments are lost. Second, if you use a RAW developer to process an image, it creates its own a sidecar file; other RAW developers are not going to be able to see that work. The benefit to building the sidecar information into the DNG file is that it keeps the whole thing together in one package, and you're standardizing the format of the sidecar information. DNG also revises the embedded JPEG file to show the updated, processed image. Adobe calls the JPEG the "work print," and the sidecar is the "notes." It's all contained in the DNG file.

At least, it is in theory. In my personal experience, some DNG-supporting software does not seem to pass on the sidecar information. This requires a good hard look at DNG file support.

What is not contained in the DNG when it is converted from a RAW file?

In the conversion to DNG, most of what is going on is described as "encoding"—rewriting the information so it can be read with a common computer language. However, some information does not get passed on in the conversion, and this has always been a big concern of mine.

The withheld information is usually information about the file that the manufacturer has chosen to not make public. This information is usually very specific to the camera, the sensor, and file processing specifications, and its only purpose is to help the manufacturer's own software to better process the file. It doesn't matter if you're using Adobe Camera RAW or some other package; if it's not the manufacturers software, then the manufacturer-specific information is not available. With DNG, nothing in the file is "dumped" during a conversion.

Just a sidenote: There is a place called "Image Maker Notes," where you can put the "secret sauce" if you're building a camera that shoots DNG. If a manufacturer wants to, they can be just as secretive about their processing "sauce" in a DNG file as they can their own files.

We mentioned it before, but a quick note about the camera profile. This is something that all processor developers have to build themselves, and again, I'm using the term "profile" very carefully to mean not only color mapping, but all the other data about the sensor. For example, there are a few noise processors—like Noise Ninja and NIK Software's Dfine—that use a camera "profile" to address noise (every camera exhibits noise in a unique way, so you can create a filter specific to that make and model to remove it). The manufacturer is not going to tell you those secrets, so you've got to build them yourself. The quality of the file is based on the quality of that "profile."

Where is the DNG format today in terms of Adobe's development and implementation?

I got a three-part answer:

PART ONE: The camera manufacturers. Adobe is happy that a few companies have produced cameras with DNG format, and two that I know of – Hasselblad and Pentax – support their own RAW format and the DNG format. Adobe politely speculated that the "major" manufacturers have bigger fish to fry. They are in the middle of the "great megapixel war," and the idea of an archival format is nice but won't sell cameras. The theory is, until major camera manufacturers start to see demand for DNG support and loss of market share due to that demand, it is not a priority. That is very kind and diplomatic of Adobe; other software developers I spoke with were less than

generous. One engineer for a big software company, who shall remain anonymous, said the major players simply laughed off DNG shooting entirely. They didn't even consider it a serious question. Only more time, and the market, will tell how open these manufacturers will be to DNG.

PART TWO: The software companies. There has been very good support for DNG by the database developers and the independent RAW file processers. From their perspective it's a selling feature of their software, and for the most part seem to universally welcome the DNG standard.

PART THREE: The photographers. Adobe's numbers state that 10% of all professional photographers are using DNG in some way. My impression is that this is a pretty vague guess, but clearly there is a solid contingency of photographers who know about DNG and have at least considered it as a solution. Is 10% a good indication of how viable DNG might be as a "standardized" file format in three years? I just don't know. I will say, however, that after working as a photographer in the professional photography community for over 30 years, getting 10% of all photographers to do anything is pretty remarkable.

My Conclusions

With continued support by independent developers, the DNG is a possible cross-platform standardization solution, allowing both raw processing as well as sidecar sharing. Based on that, it could become a true long-term archiving solution. I believe that there are bigger issues in archiving digital images however, such as media, hardware, OS support, and even computer systems in general.

CHAPTER 13:

THE BIG PICTURE

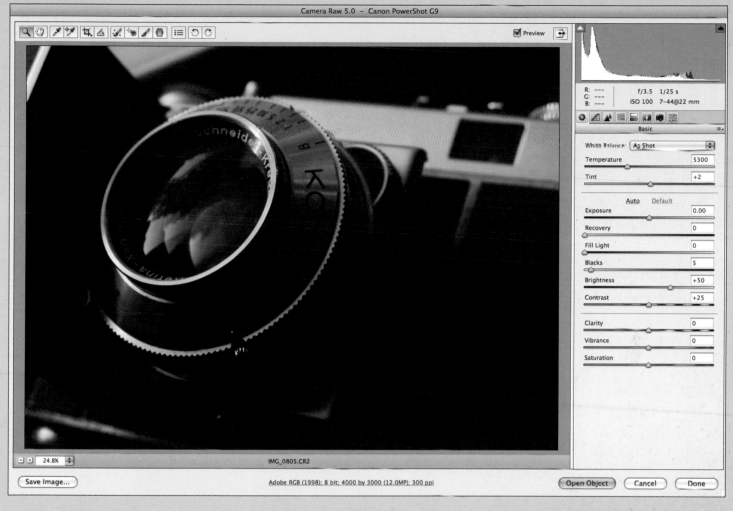

A Complete Smart Object Workflow Example

Ready to see it all together? This is what I like to call the full-on Smart Object workflow with all the trimmings. This isn't using everything we've explored, but it is an expanded example to which you can refer to create a workflow order.

Step One:
Shoot and transfer the image file.

Open the Object in Photoshop from Camera RAW by selecting the Open Object button. Name it "source" in the layer palette.

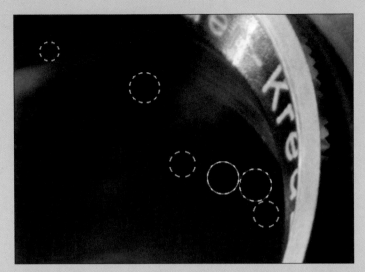

Step Two: Spot correct and initially sharpen the image.

In order to clean up the image so I can make all the other layers, I'm going to retouch spots and sharpen the RAW image file. I re-open the object and clean it up a bit. This image is kind of funky by design, so there's not a lot to fix, but there is some dust on the lens I need to take care of. I use the Clone tool in Camera RAW—it works just like the Clone tool in Photoshop—and hit OK.

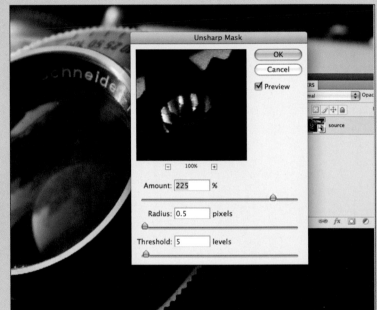

Now I'm ready to get the Unsharp Mask settings as close as I can. I check the size (Image>Image Size) and see it's about 10 x 13 inches (25.4 x 33 cm); a fine size for my usage. Then I set the Zoom to "Print Size" to see the effects of my Unsharp Mask as it will be when it gets printed. I select the settings that look good to me, hit OK, and I'm ready to rock.

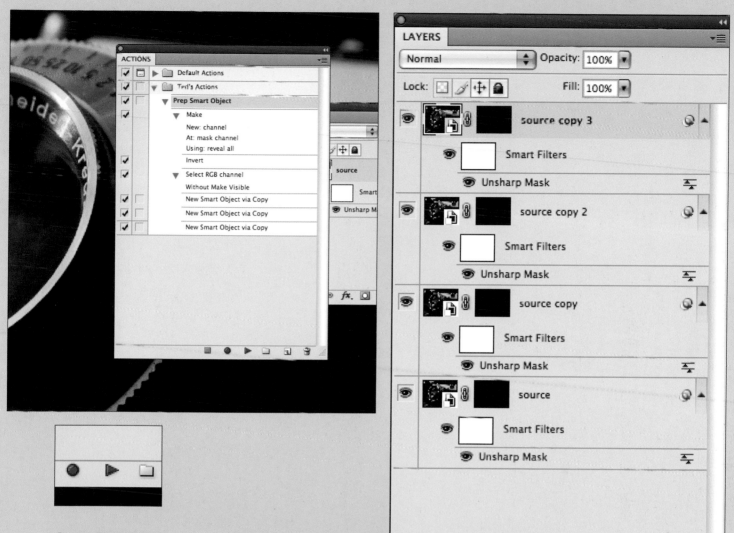

Step Three:
Use Actions to prep the file.

I pull up my Actions palette (Window>Actions),
find Ted's Actions, and my "Prep Smart
Objects" action. I hit the play button and rip
a bunch of new layers on to my image. Yay!
Now I'm ready to get to work.

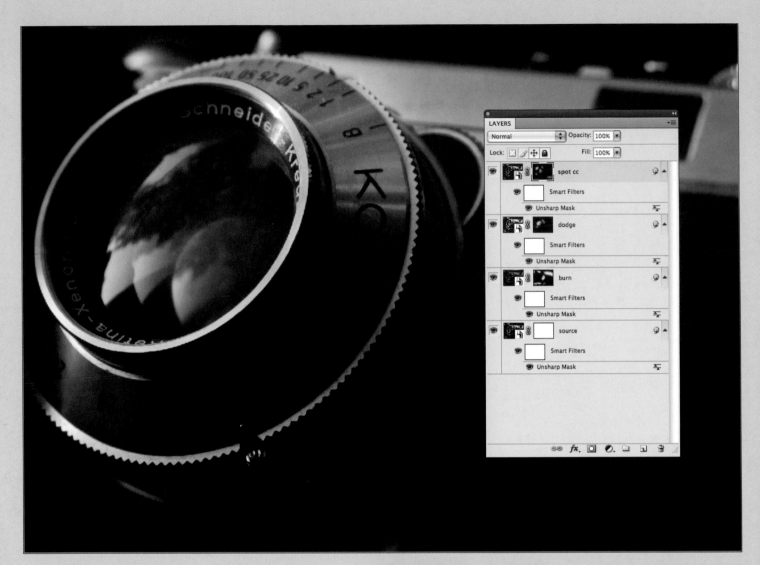

Step Four: Perform routine editing.

Here's what I've done: burned, dodged, and spot color corrected my image (see the masks?). Now, I want to show you a little thing I like to do; I grab the nice warm highlights and apply a blur to them. To do this, I go to Bridge and find the file I want. Just to keep organized, though, I'm going to use Groups to keep this all together. I select everything and go to the palette options, group my layers, and name it "basic."

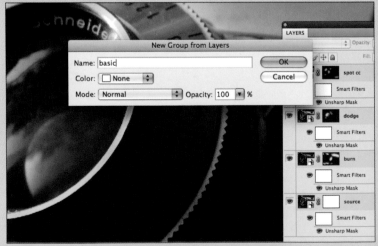

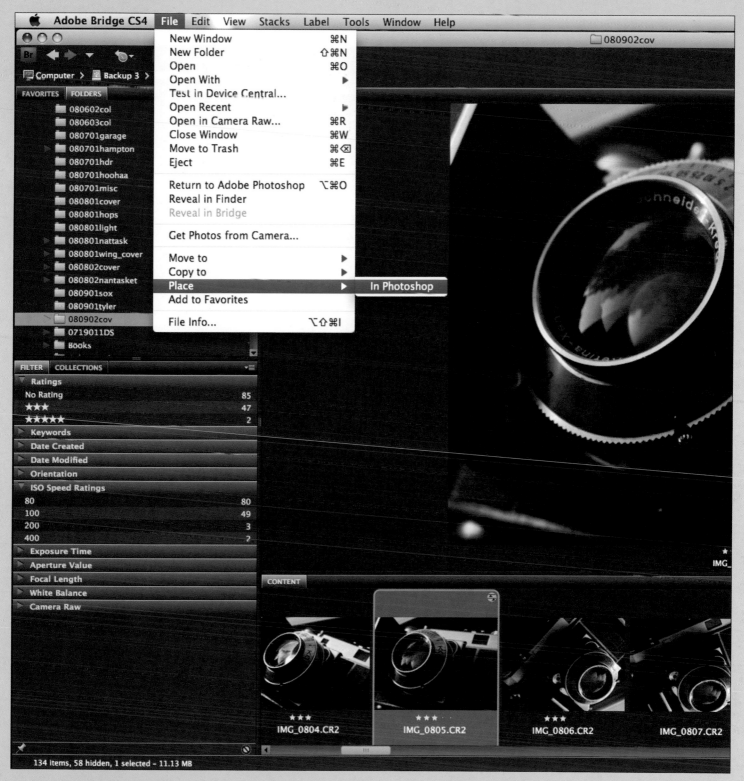

I go to Bridge, select the darker image, and go
to File>Photoshop.

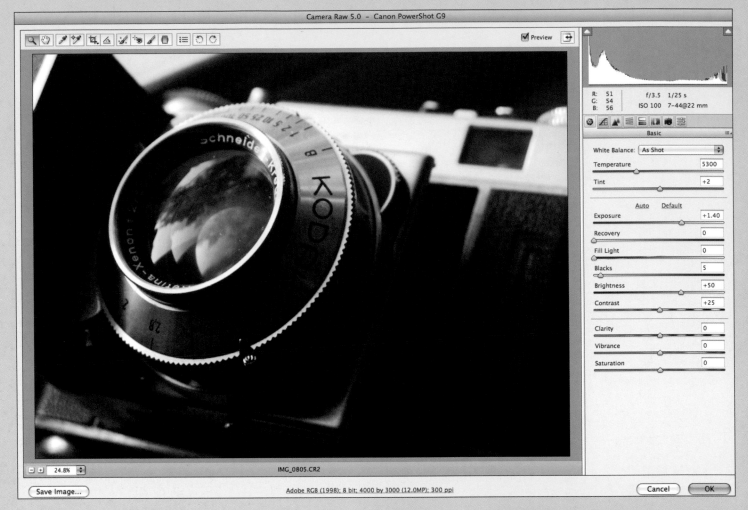

Camera Raw 5.0 – Canon PowerShot G9

Preview

R: 51 f/3.5 1/25 s
G: 54 ISO 100 7–44@22 mm
B: 56

Basic

White Balance:	As Shot
Temperature	5300
Tint	+2

Auto Default

Exposure	+1.40
Recovery	0
Fill Light	0
Blacks	5
Brightness	+50
Contrast	+25
Clarity	0
Vibrance	0
Saturation	0

24.8% IMG_0805.CR2

Save Image... Adobe RGB (1998); 8 bit; 4000 by 3000 (12.0MP); 300 ppi Cancel OK

I get the file in Adobe Camera RAW, make the image a little warmer, and pull the highlights up a bit with the Exposure slider. I hit OK, and get my "X" which I double click to "set."

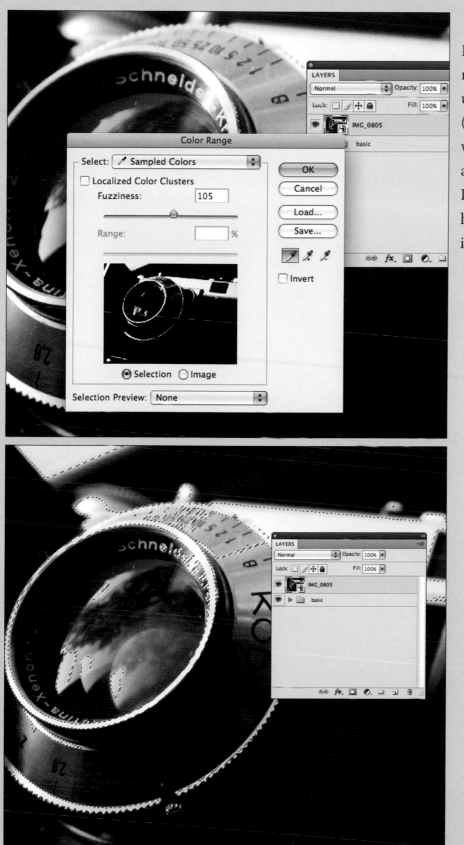

I want to make my mask, but I only need to mask for my highlights. I use the "Color Range" selection tool (Select>Color Range) to pick the warm highlights on the lens and I adjust the "Fuzziness" so it looks like I'm getting enough to work with. I hit OK, and get the marching ants indicators.

I usually like to feather this selection a bit, so I Select>Modify>Feather. I'm guessing here, but I usually go with a feather amount of around 50 pixels. I hit the mask button, and I have a nice mask for my highlights.

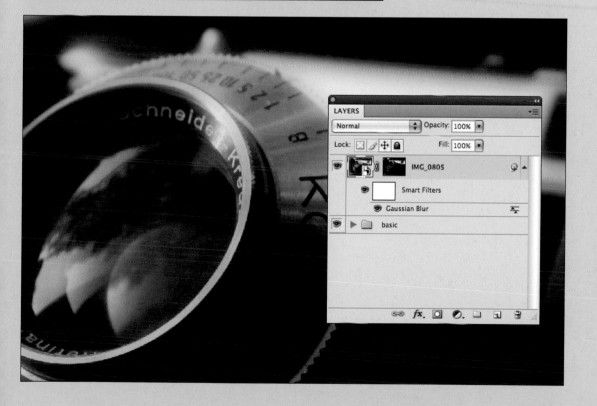

Step Five: Create a selective filter for finer adjustments.

Now I can add my Gaussian Blur Filter, which creates a nice glow around the highlights. I can always adjust the amount of glow and the areas affected by re-adjusting the filter parameters, the Mask itself, and even the opacity of the Layer. I can also turn the effect off simply by turning that layer off.

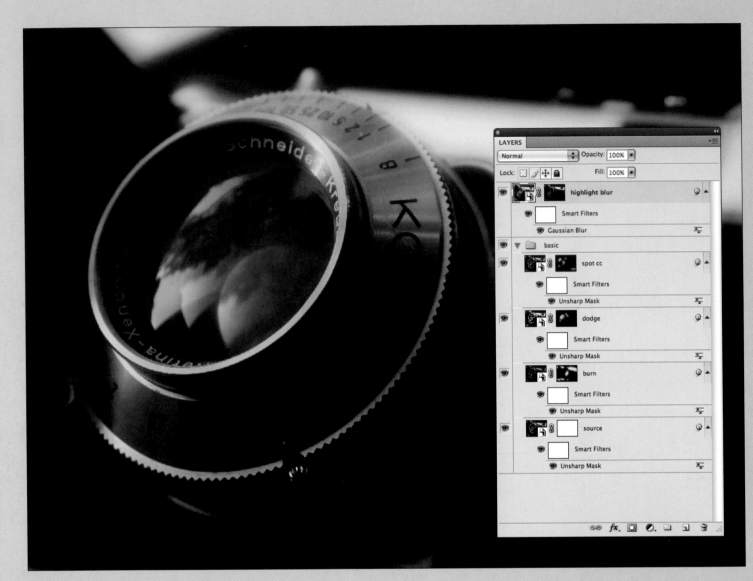

Here is a view of my final file, with the Layer
palette expanded.

Step Six: Resize for printing, final sharpening, and print the image.

Now I'm ready to print, and that leaves the two final steps: Size the image and a final sharpening edit. I usually resize the image to fit my final dimensions and try a print, since I've already sharpened with Unsharp masking. But, if I need to tweak the sharpening, I start with my source layer and move up through the layers. I probably will not tweak every layer—only the ones that have fine detail. You can't do all of them at once so you must go in and adjust the layers individually. (Now would be a good time to refer to Sharpening Strategies, on page 152.)

Print it, evaluate it under the correct print viewing light, readjust as needed, and print again. If you can get it perfect on your first print, then that is great. If not, you have a nice little roadmap to follow to go straight to your problem areas. All this, and not a single bit of image quality is lost.

Conclusion

There you have it.

If you've made it this far, you know I'm not into tricks, tips, the latest gimmicks, or the flashiest techniques. Likewise, if you've been involved in the digital photography game for any length of time, you're wise to look at any new process, workflow, or tools with suspicion and even caution. Before I even considered writing this book, I had to be convinced this process is everything it promises to be. All I can say is, I know a system is working when I can't remember how I used to do things before it came along. I use the Smart Object RAW process exclusively. I simply don't know how I'd work without it.

This is still a process and technique that seems like a "sleeper." But it's catching on slowly, and Adobe is reluctant to push very hard to a new way of working. We've seen constant, driving advances of the Smart Object RAW workflow, yet very little hype from Adobe. It's hard to escape the feeling of watching the tide come in slowly and quietly—the non-destructive editing tide.

We've come a long way. At first, when I started teaching this workflow, there were a few "inelegant" solutions—true workarounds, really—that made me hesitant to embrace it as a viable process. Now, especially with the release of Photoshop CS4 and Camera RAW 5.2, we're seeing the commitment Adobe has to this workflow (what I hope soon will be called a "constructive RAW workflow"). It is a complete package now and is only going to get better. Thomas Knoll, one of the co-architects of Photoshop, once echoed a quip, "Photoshop will, one day, be a plug-in for Camera RAW!" This hints at the power and control of editing the file in its RAW state, and may be true some day. But Camera RAW is already a place where you can do virtually everything you need to do, and Smart Objects help you do it fast and well.

Now that you've seen the Smart Object workflow, I'll repeat old Ansel Adams from the early days of digital in 1981: "I believe that the electronic image will be the next major advance. Such systems will have their own inherent and inescapable structural characteristics, and the artist and functional practitioner will again strive to comprehend and control them."

Smart Objects and RAW files are the next level of that structure, and we're well on our way to controlling them.

APPENDIX

List of Blending Modes

NOTE: Only the Normal, Dissolve, Darken, Multiply, Lighten, Linear Dodge (Add), Difference, Hue, Saturation, Color, Luminosity, Lighter Color, and Darker Color blending modes are available for 32-bit images.

Normal: Edits or paints each pixel to make it the resulting color. This is the default mode. (Normal mode is called Threshold when you're working with a bitmapped or indexed-color image.)

Dissolve: Edits or paints each pixel to make it the resulting color. However, the result color is a random replacement of the pixels with the base color or the blend color, depending on the opacity at any pixel location.

Behind: Edits or paints only on the transparent part of a layer. This mode works only in layers with Lock Transparency deselected and is analogous to painting on the back of transparent areas on a sheet of acetate.

Clear: Edits or paints each pixel and makes it transparent. This mode is available for the Shape tools (when fill region is selected), Paint Bucket tool, Brush tool, Pencil tool, Fill command, and Stroke command. You must be in a layer with Lock Transparency deselected to use this mode.

Darken: Looks at the color information in each channel and selects the base or blend color—whichever is darker—as the resulting color. Pixels lighter than the blend color are replaced, and pixels darker than the blend color do not change.

Multiply: Looks at the color information in each channel and multiplies the base color by the blend color. The resulting color is always a darker color. Multiplying any color with black produces black. Multiplying any color with white leaves the color unchanged. When you're painting with a color other than black or white, successive strokes with a painting tool produce progressively darker colors. The effect is similar to drawing on the image with multiple marking pens.

Color Burn: Looks at the color information in each channel and darkens the base color to reflect the blend color by increasing the contrast. Blending with white produces no change.

Linear Burn: Looks at the color information in each channel and darkens the base color to reflect the blend color by decreasing the brightness. Blending with white produces no change.

Lighten: Looks at the color information in each channel and selects the base or blend color—whichever is lighter—as the result color. Pixels darker than the blend color are replaced, and pixels lighter than the blend color do not change.

Screen: Looks at each channel's color information and multiplies the inverse of the blend and base colors. The result color is always a lighter color. Screening with black leaves the color unchanged. Screening with white produces white. The effect is similar to projecting multiple photographic slides on top of each other.

Color Dodge: Looks at the color information in each channel and brightens the base color to reflect the blend color by decreasing the contrast. Blending with black produces no change.

Linear Dodge (Add): Looks at the color information in each channel and brightens the base color to reflect the blend color by increasing the brightness. Blending with black produces no change.

Overlay: Multiplies or screens the colors, depending on the base color. Patterns or colors overlay the existing pixels while preserving the highlights and shadows of the base color. The base color is not replaced, but mixed with the blend color to reflect the lightness or darkness of the original color.

Soft Light: Darkens or lightens the colors, depending on the blend color. The effect is similar to shining a diffused spotlight on the image. If the blend color (light source) is lighter than 50% gray, the image is lightened as if it were dodged. If the blend color is darker than 50% gray, the image is darkened as if it were burned in.

Painting with pure black or white produces a distinctly darker or lighter area, but does not result in pure black or white.

Hard Light: Multiplies or screens the colors, depending on the blend color. The effect is similar to shining a harsh spotlight on the image. If the blend color (light source) is lighter than 50% gray, the image is lightened, as if it were screened. This is useful for adding highlights to an image. If the blend color is darker than 50% gray, the image is darkened, as if it were multiplied. This is useful for adding shadows to an image. Painting with pure black or white results in pure black or white.

Vivid Light: Burns or dodges the colors by increasing or decreasing the contrast, depending on the blend color. If the blend color (light source) is lighter than 50% gray, the image is lightened by decreasing the contrast. If the blend color is darker than 50% gray, the image is darkened by increasing the contrast.

Linear Light: Burns or dodges the colors by decreasing or increasing the brightness, depending on the blend color. If the blend color (light source) is lighter than 50% gray, the image is lightened by increasing the brightness. If the blend color is darker than 50% gray, the image is darkened by decreasing the brightness.

Pin Light: Replaces the colors, depending on the blend color. If the blend color (light source) is lighter than 50% gray, pixels darker than the blend color are replaced, and pixels lighter than the blend color do not change. If the blend color is darker than 50% gray, pixels lighter than the blend color are replaced, and pixels darker than the blend color do not change. This is useful for adding special effects to an image.

Hard Mix: Adds the red, green and blue channel values of the blend color to the RGB values of the base color. If the resulting sum for a channel is 255 or greater, it receives a value of 255; if less than 255, a value of 0. Therefore, all blended pixels have red, green, and blue channel values of either 0 or 255. This changes all pixels to primary colors: red, green, blue, cyan, yellow, magenta, white, or black.

Difference: Looks at the color information in each channel and subtracts either the blend color from the base color or the base color from the blend color, depending on which has the greater brightness value. Blending with white inverts the base color values; blending with black produces no change.

Exclusion: Creates an effect similar to but lower in contrast than the Difference mode. Blending with white inverts the base color values. Blending with black produces no change.

Hue: Creates a result color with the luminance and saturation of the base color and the hue of the blend color.

Saturation: Creates a result color with the luminance and hue of the base color and the saturation of the blend color. Painting with this mode in an area with no (0) saturation (gray) causes no change.

Color: Creates a result color with the luminance of the base color and the hue and saturation of the blend color. This preserves the gray levels in the image and is useful for coloring monochrome images and for tinting color images.

Luminosity: Creates a result color with the hue and saturation of the base color and the luminance of the blend color. This mode creates the inverse effect of Color mode.

Lighter Color: Compares the total of all channel values for the blend and base color and displays the higher value color. Lighter Color does not produce a third color, which can result from the Lighten blend, because it chooses the highest channel values from both the base and blend color to create the result color.

Darker Color: Compares the total of all channel values for the blend and base color and displays the lower value color. Darker Color does not produce a third color, which can result from the Darken blend, because it chooses the lowest channel values from both the base and the blend color to create the result color.

To read more about Adobe's Blending Modes, go to http://livedocs.adobe.com/en_US/ Photoshop/10.0/WSfd1234e1c4b69f30ea53e-41001031ab64-77e9.html

INDEX

A

actions 162, 178, 187, **229**-236

A/D converter 23

adjustment brush **46**-48, 138

adjustment layers 15, **104**, 111, 112, 113, 130, 131, 158, 160, 166, 199, 202, 208, 239

Adobe

Bridge 38, 59, 90, **92**-99, 136, 144, 161, 163, 242, 266, 267
Camera RAW
15, 17, 19, 20, 24, **38**, 126, 128, 136, 137, 138, 144, 146, 161, 162, 183, 187, 188, 199, 201, 202, 211, 226, 227, 238, 242, 245, 250, 252, 257, 258, 259, 263, 264, 270, 279
Camera RAW primer **38-90**
Lightroom 90, 92, **238**-239, 258
Photoshop 12, 15, 17, 19, 20, 25, 31, 32, 34, 37, 39, 40, 42, 43, 54, 55, 72, 78, 81, 83, 89, 92, 98, **100**, 101, 102, 114, 117, 121, 122, 123, 128, 130, 135, 137, 138, 144, 145, 147, 153, 158, 161, 162, 163, 165, 174, 183, 184, 185, 187, 188, 199, 201, 208, 210, 226, 229, 234, 238, 241, 245, 252, 263, 264, 267, 279

alias 202

archive 24, 126, **252**-257, 259, 260

B

Bayer Array **20**, 24

bit depth 23, **28**-31, 54, 136, 242

brightness 20, 24, 25, 27, 64, 69, 74, 78, 104, 145, 146, 180, 243

brush tool 111, 114, 116, 117, 158, 168

burn 117, 126, **157**, 158, 160, 165, 166, 168, 178, 180, 181, 187, 190, 213, 214, 246, 247, 266

C

calibrate 76, 78

channel mixer 81

clone tool 140, 183, **184**, 185, 264

color management **32**-34, 83, 145, 146, **174**

Color Picker **20**, 78, 80, 111

color space 32, 33, 34, **54**, 75, 82, 136, 174

contrast **23**, 24, 37, 54, 56, 62, 67, 68, 69, 71, 73, 88, 90, 138, 150, 153, 202

crop tool **43**, 44, 51, 210-211

curves 20, 26, **70**, 71, 72, 85, 138, 157

D

demosaic **25**, 73

digital hygiene 207

DNG 54, 86, 128, 257, **258**-260